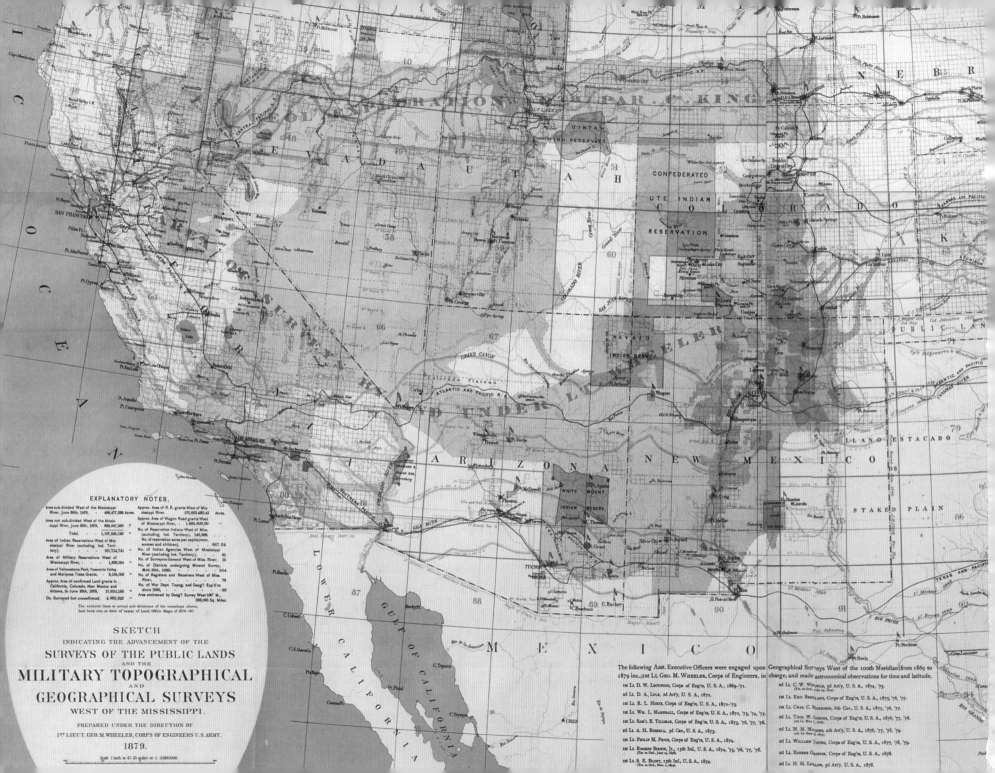

SKETCH
INDICATING THE ADVANCEMENT OF THE
SURVEYS OF THE PUBLIC LANDS
AND THE
MILITARY TOPOGRAPHICAL
AND
GEOGRAPHICAL SURVEYS
WEST OF THE MISSISSIPPI.

PREPARED UNDER THE DIRECTION OF
1ST LIEUT. GEO. M. WHEELER, CORPS OF ENGINEERS U.S. ARMY.
1879.

Scale 1 inch to 47.35 miles or 1: 3,000,000

ONE/MANY: WESTERN AMERICAN SURVEY PHOTOGRAPHS BY BELL AND O'SULLIVAN

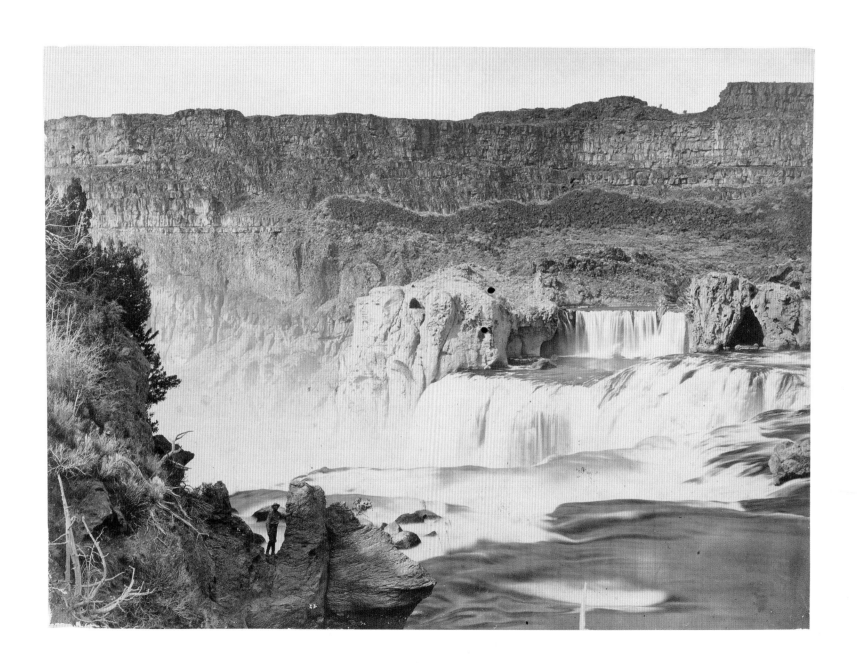

ONE/MANY

Western American Survey Photographs by Bell and O'Sullivan

JOEL SNYDER

WITH CONTRIBUTIONS BY JOSH ELLENBOGEN

The David and Alfred Smart Museum of Art
THE UNIVERSITY OF CHICAGO

Catalogue published in conjunction with the exhibition
One/Many: Western American Survey Photographs by Bell and O'Sullivan
The David and Alfred Smart Museum of Art
The University of Chicago
February 2–May 7, 2006

Copyright ©2006
The David and Alfred Smart Museum of Art
The University of Chicago
5550 South Greenwood Avenue
Chicago, Illinois 60637
(773) 702-0200
www.smartmuseum.uchicago.edu
All rights reserved.

Project Editor: Anne Leonard
Copy Editor: Katherine E. Reilly
Design and typesetting: Joan Sommers Design, Chicago
Color separations: Professional Graphics, Rockford
Printed in China by Asia Pacific Offset

Library of Congress Cataloging-in-Publication Data
Snyder, Joel.
 One/many : Western American survey photographs by Bell and O'Sullivan /
Joel Snyder ; with contributions by Josh Ellenbogen.
 p. cm.
 "Catalogue published in conjunction with the exhibition 'One/Many: Western
American Survey Photographs by Bell and O'Sullivan,' The David and Alfred Smart
Museum of Art, The University of Chicago, February 2–May 7, 2006."
 ISBN-13: 978-0-935573-43-5 (alk. paper)
 1. Photography, Panoramic–West (U.S.)–History–19th century–Exhibitions.
2. Landscape photography–West (U.S.)–History–19th century–Exhibitions.
3. O'Sullivan, Timothy H., 1840–1882–Exhibitions. 4. Bell, William, 1830–1910–
Exhibitions. 5. West (U.S.)–History–19th century–Pictorial works–Exhibitions.
I. Ellenbogen, Josh. II. O'Sullivan, Timothy H., 1840–1882. III. Bell, William,
1830–1910. IV. David and Alfred Smart Museum of Art. V. Title.
 TR661.S69 2006
 779'.36780922–dc22
 2005029792

This catalogue is funded by an endowment established by the Andrew W.
Mellon Foundation at the Smart Museum of Art at the University of Chicago,
the Smart Family Foundation, and the Elizabeth F. Cheney Foundation.
Additional support has been provided by the Rhoades Foundation, Tom
and Janis McCormick and the Kanter Family Foundation, and Nuveen
Investments. Lead corporate sponsor of the related exhibition: LaSalle Bank.

LaSalle Bank
ABN AMRO

Front cover and reverse cover: William Bell, *Canyon and Headlands of Colorado and Paria Rivers*, 1872 (cat. 46d–e)

Reverse cover: Timothy O'Sullivan, *Shoshone Falls, Snake River, Idaho*, ca. 1868 (cat. 10)

Endsheets: *Sketch indicating the advancement of the surveys of the public lands and the military, topographical, and geographical surveys west of the Mississippi.* Survey map, 1879. (cat. 76)

Frontispiece: Timothy O'Sullivan, *Shoshone Falls, Snake River, Idaho, Midday View*, 1874 (cat. 40)

Photography Credits: Photography by Tom Van Eynde unless otherwise noted; fig. 1, plates 13, 16, 19, 22, 23, 25, Professional Graphics for the LaSalle Bank Photography Collection; figs. 4, 5, 6, 7, 8, 20 (middle panel), 27, 28, 30, 32, National Archives and Records Administration; fig. 17, plates 2, 15, 21, 26, 30, Center for Creative Photography, University of Arizona, Tucson; figs. 22, 23, 31, George Eastman House.

Contents

For Bob and Joan Feitler
with admiration and gratitude

Preface and Acknowledgments

SOME OF THE MOST CELEBRATED images of nineteenth-century American photography emerged from government-sponsored geological surveys whose purpose was to study and document western landscapes. Timothy O'Sullivan and William Bell, two survey photographers who joined expeditions in the 1860s and 1870s, helped open the eyes of Americans to the western frontier. In 2003 the Smart Museum purchased approximately three dozen works that Bell and O'Sullivan produced during expeditions led by George M. Wheeler. This group had been in the Gedney family since the 1870s; both J. F. Gedney and Charles DeForest Gedney were associated with the geological surveys in those years, whether through direct participation or through contacts with the survey photographers. The continuous provenance of this group of photographs increased its value as a study collection, as did the substantial representation—nearly twenty photographs—of works by the little-known Bell. Particularly intriguing among those were the photographs taken as a series to form panoramas. The extreme difficulty of photographing and assembling multishot panoramas in the field merited an inquiry into the motivations for their production, the ways in which they were displayed (whether simultaneously or serially), and the reasons for their popularity.

The opportunity to acquire the Gedney collection was all the more compelling because of the potential to collaborate with our colleague Joel Snyder, Professor of Art History at the University of Chicago, whose book *American Frontiers* (1981) is a landmark in O'Sullivan studies. The present exhibition and catalogue would never have been possible without his expertise and commitment.

Ready access to extraordinary faculty members is one of the chief distinctions of life at a major university art museum. *One/Many: Western American Survey Photographs by Bell and O'Sullivan* represents the latest in a series of exhibitions focusing on the Smart Museum's collection that have involved faculty members serving as curators. For the better part of a decade, the generous support of the Andrew W. Mellon Foundation has allowed the museum to

Cat. 11

undertake these successful Mellon Project exhibitions, whose hallmark has been intellectual rigor paired with broad appeal to our audiences on and off campus.

The title *One/Many*, intended to suggest the double status of photographic panoramas as singular and multiple objects, is also a fitting reminder that this exhibition represents the joining together of many individuals' efforts. First among those deserving recognition is Joel Snyder, whose multifaceted contribution to the project—as curator, principal catalogue author, advisor, and lender—exemplifies his longstanding support for the Smart Museum and its core mission. He brought to the project not only a seasoned scholarly perspective on survey photography, born of many years of reflection upon it, but also a newer and equally passionate intellectual engagement with the "panoramic puzzle." We are also grateful to Josh Ellenbogen, an advanced Art History graduate student, who willingly took on the responsibility of producing a catalogue essay even as he completed his doctorate and prepared to move on to an academic position.

The photographs of the Gedney collection could only be fully understood in the context of critical works lent to the project by individuals and institutions. The lenders deserve our thanks for their kindness and generosity. These include Michael Mattis and Judith Hochberg, whose collection is renowned for its depth and quality, and Joel Snyder. Institutional lenders to whom we owe particular thanks are the Art Institute of Chicago, James Cuno, Director and President, and David Travis, Curator of Photography; the Center for Creative Photography at the University of Arizona in Tucson, Douglas Nickel, Director, and Britt Salvesen, Curator; and the LaSalle Bank Photography Collection, Carol Ehlers, Curator, and Whitney Bradshaw, Assistant Curator. As in previous Mellon Projects, Alice Schreyer was willing to lend from the rich trove at the Special Collections Research Center, University of Chicago Library. At the University of Chicago's Crerar Library, we owe thanks to Kathleen Zar, Science Librarian, and, at the University Library's Map Collection, bibliographer Christopher Winters was very helpful.

Several professionals contributed greatly to the success of this project. Joan Sommers designed this catalogue with her customary mix of good taste, patience, and grace under pressure. Pat Goley of ProGraphics ensured that the reproductions did justice to the original photographs. Katie Reilly provided expert copyediting, and Dan Cochrane, photography conservator, assisted at a critical moment. Jim Iska applied his skilled hand to matting the photographs. At the Smart Museum, every staff member performed with a remarkable degree of professionalism and good cheer. Kim Rorschach, now the Mary D. B. T. and James H. Semans Director of the Nasher Museum at Duke University, conceived of the project with Joel Snyder during her tenure as the Smart Museum's Dana Feitler Director. Jacqueline Terrassa, now Deputy Director for Collections, Programs, and Interpretation, shepherded the project during nearly a year's service as Interim Director and has lent her considerable expertise to the educational programs created in concert with the exhibition. Shaleane Gee, Deputy Director for Development and External Affairs, led the effort to find support for and promote the exhibition. Rudy Bernal, Chief Preparator and Facilities Manager, and Lindsay Artwick, Registrar, brought their usual attentiveness to this project.

Irene Backus, a graduate student in the Art History Department and Curatorial Intern for Mellon Projects, provided superb support. And no member of the staff deserves greater thanks than Anne Leonard, Mellon Curator, who has been involved with every aspect of this project and has displayed extraordinary wisdom, professional skill, and poise throughout. The project could never have come to fruition without her.

Finally, we owe a deep debt to those who provided the funding that made this exhibition a reality. LaSalle Bank's lead corporate sponsorship was critical. The Smart Family Foundation offered support, as it has so often over the years; the museum would be a much less ambitious place without their significant, consistent, and thoughtful generosity. We also thank the Andrew W. Mellon Foundation, as well as the Rhoades Foundation, for their continued financial backing of the Mellon Projects. The Elizabeth F. Cheney Foundation has again offered support for the publication of a Smart Museum catalogue, and we are grateful for the foundation's continuing vote of confidence in us. Tom and Janis McCormick and the Kanter Family Foundation, as well as Nuveen Investments, have provided vital funding for the Smart Museum's exhibition program. We could not succeed without them.

We hope that *One/Many* offers new perspectives not only on the photographs by Timothy O'Sullivan and William Bell now in the collection of the Smart Museum of Art but also more generally on American photography of the West in the nineteenth century and its reception by an eager public. It is a privilege for us to be able to share this material with a wide audience.

Anthony Hirschel
Dana Feitler Director

JOEL SNYDER

Photography on the Western Surveys

THE AMERICAN EXPEDITIONARY PHOTOGRAPHS Timothy H. O'Sullivan and William Bell produced in the 1860s and 1870s were well known at the time of their publication in the 1870s to a small audience of expert geologists, naturalists, mapmakers, military officers, and politicians. They were included in the official photographic albums of the expeditions led by Clarence King and George Wheeler, were viewed as stereographic cards inserted in stereoscopes, and appeared in lithographic form as illustrations in the expeditions' impressive interim and final reports. The photographs were also presented occasionally to the public through inclusion in government-sponsored exhibitions—for instance, fourteen framed prints were shown at the Philadelphia Centennial Exposition (1876) along with stereographic views (which were also available through E. and H. T. Anthony, a commercial supply house for the photographic trade). Nevertheless, these images failed to capture the imagination of a broad popular audience at the time they were made and finally lost even

Cat. 55

the attention of professional geologists, botanists, ethnographers, and allied professionals as their disciplines devised new techniques of investigation and analysis.

In the mid-1930s Timothy O'Sullivan's photographs were once again brought to public notice, but the attention accorded to them this time was quite different. The new fascination with the photographs was catalyzed by what the photographer Ansel Adams saw as their aesthetic character—quite apart from their functional value. In early 1936 Adams showed his own, recently purchased album of photographs by O'Sullivan and Bell to Beaumont Newhall, then a librarian at the recently incorporated Museum of Modern Art in New York, who was preparing a massive exhibition, *Photography, 1839–1937*.[1] Newhall was impressed by the album and hung one of the O'Sullivan exploration prints in the show.[2] Later, he included examples of O'Sullivan's Civil War and exploration photographs in his highly popular *History of Photography*, a book that has served for nearly fifty years to popularize photography as an independent medium capable of producing works of aesthetic value (figure 1). This new interest in O'Sullivan's photographs grew out of a self-conscious attempt by a small group of photographers and writers/curators to establish a tradition of photographic practices and a canon of works that would authenticate their own preferences and critical interests.

Photographers as diverse as Berenice Abbott, Ansel Adams, Walker Evans, Ralph Steiner, Paul Strand, and Edward Weston, as well as critic/curator/writers like Lincoln Kirstein and Beaumont Newhall repeatedly referenced the Civil War photographs of Mathew Brady as touchstones that exemplified the spirit of the photographic practice each

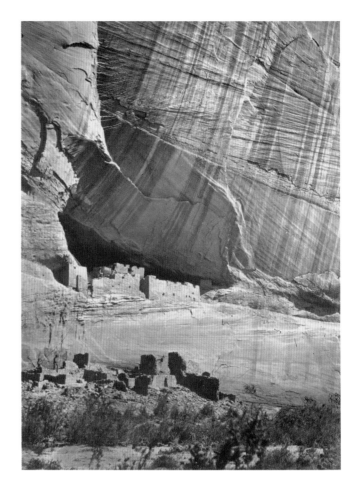

FIGURE I

"Timothy O'Sullivan, *Ancient ruins in the Cañon de Chelle, New Mexico, in a niche fifty feet above the present cañon bed*, 1873. From *Photographs. . . Geographical Explorations and Surveys West of the 100th Meridian, War Department, Corps of Engineers, U.S. Army, 1871–1873*. Lent by Ansel Adams, San Francisco."
[Caption from Beaumont Newhall's exhibition catalogue]
Cat. 24

championed. It is ironic that in choosing Brady, they had quite honestly but mistakenly identified him with the many different photographers whose work had been published under his name during the Civil War.[3]

The elevation of O'Sullivan's western exploration photographs to the emerging photographic canon was predicated on the principle adopted by nearly all American avant-garde photographers of the 1930s—no matter how much they might have disagreed about its elaboration—that photography was different in kind from all other representational media. The driving idea was that photographs were generated by modern, industrial-technological means and that they therefore had a new and fundamentally different aesthetic from handmade pictures. The merits of good photographs were held to be peculiar to photography; in this view, the worst thing a photographer could do would be to confuse the criteria for evaluating paintings with those they said were inherent to photography. Weston criticized and caricatured this confusion by pointing to what he called "the photo-painting standard"—the criterion adopted by photographers who strove to make old-fashioned works of art with the modern technology of photography by emulating the pictorial habits and preferences of painters. In attempting to escape the influence of painting, Weston, Strand, and a small but influential handful of photographers and writers of the time looked for the distinguishing marks of photography—the traits that separated it from all other media—and insisted that these characteristics (among them delineation of fine detail, inhuman precision, instantaneity) were responsible for its special aesthetic qualities. They maintained that the challenge of significant photography was to escape from the genres, the content, and the effects of painting by establishing values that were consonant with the technology of photography.

In assembling a canon and constructing a tradition, these photographers sought out the work of those practitioners of the past whom they judged to have been engaged in the "honest" and "direct" work of "recording" the facts that lay before their cameras. The photographs of the Civil War seemed exemplary in this regard. So too was the work of a few of the photographers from the post–Civil War exploration surveys—men like O'Sullivan. The aesthetic value of O'Sullivan's photographs was achieved "honestly," because unselfconsciously. Without artistic pretensions or intentions, photographers like O'Sullivan, it was argued, were able to emphasize the essential features of photography, and, in doing so, produce work that was purely photographic—free of the formulae of painting. O'Sullivan's art was made possible by his innocence of painting and his commitment to honest, hard work.

I suspect that part of the motivation for choosing O'Sullivan's prints as early and previously unnoted exemplars of photographic art had everything to do with the American placement of the surveys and with what must have been seen as the innocent American character of the photographers.[4] Even though Newhall and Adams had respect for and interest in European photography, the medium seemed to them somehow especially at home and in particularly fertile soil in America.[5] The photographer Alfred Stieglitz, whose persona and proclamations had a constant and profound effect on Newhall and Adams, was mesmerized by the possibilities of photography as an

American art.[6] But quite beyond this, even as it was critical of America, the photographic avant-garde was deeply, self-consciously American. Walker Evans's 1938 exhibition at the Museum of Modern Art carried the simple title *American Photographs*.

BACKGROUND

The widespread commercial practice of photography, understood as a system for producing paper prints from negatives, dates to the mid- to late 1850s. Prior to this time, daguerreotypes—one-of-a-kind pictures made on highly polished, silver-plated copper—had dominated the commerce in camera-made pictures. In the United States, the transition from the daguerreotype to the negative/positive system of print production was abrupt and stunning. Within a three- or four-year period, starting around 1855, the trade in photographic prints grew exponentially. Photographic portraits on paper became articles of commerce, as did miniature portraits on small cards (*cartes de visite*), three-dimensional stereographic views, and full-plate (6½-by-8½–inch) and larger prints of places of civic, national, and international significance. By the end of the American Civil War, the photographic industry in the United States was producing millions of prints annually; sales reached into the homes of the wealthy and the middle class, onto the desks of the managers of corporations and government officials, and into the libraries of cities, governments, schools, and universities. The popular culture of the United States was transformed; citizens were educated by viewing stereographic cards in easy-to-use stereoscopes, learning the features of Mont Blanc and Mount Whitney, studying the important sites of Christianity in Jerusalem and Rome, and viewing the buildings and interiors of Mount Vernon, for example. Photographic portraits in the form of *cartes de visite* were purchased in enormous numbers, both for personal use and for dissemination to distant relatives and friends. Special albums for *cartes de visite* were sold by photographic studios and included pockets for the insertion of diminutive portraits of national leaders, prominent military officers, and celebrities in the arts and sciences, which were sold through the mail or purchased at the local photographer's studio.

Photography was a commerce, though most photographers earned a rather humble living at it, often with the help of their families. They spent most of their work time making portraits and painstakingly producing multiple prints from negatives, but the profits from portrait photography were small for the most part and many sought various means for supplementing their incomes. Some produced post-mortem pictures of the dead in their homes or made views of local points of interest that became part of their sales inventories. Highly successful photographers were primarily energetic entrepreneurs. Most of them, like Mathew Brady, had their names letterpressed on their photographic mounts, but though they were called "photographers," they happily surrendered the work of taking pictures to "operators," who posed the patron and made the exposure, and to low-skilled laborers who produced prints, one at a time, from the negatives. The photographer's name on a mount was not necessarily the mark of authorship; it served as a trademark or brand name.

The proliferation of print forms—stereographs, *cartes de visite*, large, larger, and life-size photographic portraits,

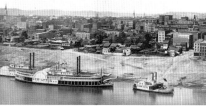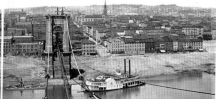

FIGURE 2

J. W. Winder, *View of Cincinnati, Ohio*, ca. 1866. Albumen print Photograph: Library of Congress

monochrome, hand-colored, or worked over in India ink—coincided with the marketing of saleable items like *cartes de visite*, larger views of faraway places (purchased from other photographers and supply houses), stereographic views and boxes for their storage, albums at various prices covered in leather or fabric, and Bibles with pre-cut slots for the insertion of photographic portraits. By the early 1860s, photographers added another item to their inventories: multiple-print panoramic views of their local towns (see figure 2).

Photographic print culture borrowed heavily from the older, conventional print culture in terms of subject matter and manner of presentation. In very short order, a reciprocal relation was established between wood and steel engraving, lithography, and photographic prints. Photographs, however, were not easily assimilated into books until well into the 1880s, because they could not be reproduced in ink as inexpensively as the older, type-compatible print media. With relatively few exceptions, photographs entered books and magazines via hand-copying—they served as the models for lithographs and prints rendered in other graphic media. Their flaws, from the standpoint of conventional book

illustration, were generally "corrected" or deleted by the copyist, who would often insert clouds into blank, feature-less skies and position human figures where none appeared in the photograph.

EXPLORATION

With the close of the Civil War in the spring of 1865, the national government, freed from the necessity of prosecuting a massive war and no longer vexed by the question of whether new states should be admitted as free or slave, returned to the pressing matter of the American West. The Louisiana Purchase of 1803 had added roughly 828,000 square miles to the landmass of the country—a territory that included at least part of the present-day states of Arkansas, Colorado, Iowa, Kansas, Louisiana, Minnesota, Missouri, Montana, Nebraska, North Dakota, Oklahoma, South Dakota, and Wyoming. Additionally, the war between the United States and Mexico (1846–1848), which ended with the Treaty of Guadalupe Hidalgo, had added another 525,000 square miles to the territories of the United States. This land, ceded by Mexico at the point of a bayonet and

"purchased" for fifteen million dollars, included large portions of present-day Arizona and New Mexico, parts of Texas, western Colorado, and all of California, Nevada, and Utah. The treaty, along with the 1853 Gadsden Purchase, which added Mexican land to what is now Arizona and New Mexico, completed the continental expansion of the United States. These vast western regions remained unknown and unexplored in a systematic manner, even as thousands of people—miners, farmers, ranchers, shopkeepers—were settling there and two railroads were pushing from east and west to complete a transcontinental railway.[7] By the mid-1860s, even regional western railroads were in the process of planning and construction, with the hope that they would serve the suddenly burgeoning mining, agriculture, and real-estate interests.

The first of the expeditions to the West was led by the young, Yale-educated civilian scientist Clarence King and began its first field season in the late spring of 1867. Three other expeditions led by Ferdinand Vandiveer Hayden, John Wesley Powell, and 1st Lt. George M. Wheeler received full annual funding from the federal government and initiated their field work in the years between 1869 and 1871. These four survey teams worked competitively, often crisscrossing each other's tracks, and on one or two occasions coming into direct conflict. The politics, the texts and subtexts of the competition between the survey groups for initial federal funding, for re-funding from Congress, and for popular attention was constant and wearying. The military wanted to exercise direct command over all the expeditions, and ultimately had nominal control of three, though only the Wheeler survey was headed by an active military officer.

Each of the surveys included a photographer on its staff. O'Sullivan worked for Clarence King the field seasons of 1867–1869 and 1872, and for Wheeler in 1871, 1873, and 1874.[8] William Bell filled in for O'Sullivan in 1872, accompanying Wheeler to the West from May through September.

The goals of the western expeditions were diverse, and each tended to emphasize the interests of its leader. King, who had trained as a geologist at Yale, outlined the scope of his expedition's aims on the first page of *Systematic Geology*, the first tome of the seven-volume final report: "The explorations of the Fortieth Parallel promised, first, a study of the natural resources of the mountain country near the Union and Central Pacific railroads: secondly, the completion of a continuous geological section across the widest expansion of the great Cordilleran Mountain System."[9] The natural resources referred to by King included gold, silver, and, equally important, coal, which was needed to fuel the rapidly expanding western railroads and cities.

The disposition of each of the surveys was mixed—disinterested and interested, "purely scientific" and utterly practical. Although some historians have attempted to reduce the complex of goals and motives to a single one—economics—the reduction leads to a significant loss of the substance and texture of the surveys. It is certainly true that mining was high up on the list of incentives to put the expeditions into the field, and that the geological investigations were tied, in part, to understanding the ways in which gold and silver had initially been deposited and had subsequently shifted over time in the West. Similarly, the production of detailed and accurate maps served both mining interests and the railroads. But the maps also met the needs of the

military, which are arguably more distantly related to economic matters. One problem with reducing disparate motives bound up in the various surveys to a single economic incentive is that it fails to explain why the Wheeler and King surveys devoted so much time and energy to the study of botany, microscopical petrography, onodorinthes, paleontology, ethnography, archaeology, and ornithology.[10]

The careerism of the individual chiefs of the expeditions had a strong influence on the nature of their investigations, and institutional pressures played a formative role in the choice of personnel for the surveys. For example, the Department of War, which had educated three generations of soldier-engineers at West Point and Annapolis and had conducted mapping surveys and explorations of the West prior to the Civil War, was losing out to civilian engineers and scientists educated at non-military colleges. Clarence King, who took charge of the Fortieth Parallel explorations in 1867 at the age of twenty-five, was nominally under the control of the Army Corps of Engineers, but hired only civilians to supervise the collection of data and specimens. To make matters worse for the military, King had taken leave of the East for the duration of the war while working in California under the tutelage of Professor Josiah D. Whitney.

There was extra pressure on Wheeler's military-led survey to outperform the civilian expeditions, particularly King's. Wheeler, who had married into a politically prominent and powerful family, was keenly interested—like King—in the public promotion of the surveys. He agreed to allow Frederick W. Loring, a recent graduate of Harvard who had a promising career as a writer, to join the expedition as a correspondent for *Appleton's Journal*. Loring dispatched

short essays from the field in Wheeler's first survey year (1871) to the periodical. Wheeler's interest in publicity helps account for this generous description of the goals of his survey in *Harper's Weekly*, which appeared just as his team began its initial work in the field.

We have heretofore referred to an expedition under Lieutenant G. M. Wheeler, U.S.A., as among those now fitting out for service in the field; and we now learn that the work is to be prosecuted with the thoroughness that characterizes all the undertakings of the Engineer Department. As already stated, the field in question embraces a large area, and that of a comparatively little known country, south of the Central Pacific Railroad, including portions of southern and southwestern Nevada, southeastern California, southwestern Utah, some of the lower cañons of the Colorado, and extending into eastern and northeastern Arizona, with perhaps some points in New Mexico, and covering an aggregate of about sixty thousand square miles. The primary object of the expedition is, of course, the acquisition of a correct topographical knowledge of the country, and the means of preparing accurate maps, by which military movements can be arranged, and the best positions for settlement determined. The proper sites for military posts will be looked after, and a careful inquiry prosecuted into the character, disposition, and statistics of the Indians inhabiting the country. Of the more purely scientific work of the survey the practical geological and mining resources of the region will receive special attention. The expedition will be accompanied by gentlemen competent to settle these points, and much care will be directed also toward procuring a complete series of the animals and plants; so. . . that a satisfactory knowledge of the whole country

can be established. Great attention will be given to the astronomical determinations, and a competent photographer will accompany the expedition. This will probably be divided into two parties—one under the direction of Lieutenant Wheeler himself, and the other under that of Lieutenant D. W. Lockwood. We shall await with great interest the result of the operations of this exploration, which, it is thought, may occupy several years for its completion, but which can not fail, year by year, to bring to light much information concerning this interesting but little known portion of our country. [11]

This statement is important for what it tells us about the comprehensiveness of the expedition, but, equally for the purpose of this essay, it demonstrates the desire on the part of its sponsors for the word to go out to the wider public. The note also sheds light on how science was figured in the period of the surveys. The unidentified author writes: "Of the more purely scientific work of the survey the practical geological and mining resources of the region will receive special attention." It is this thoroughgoing admixture of the practical and the disinterested that characterizes almost all the work of the surveys and their reception as well.

Historians have argued for more than two decades about the function of photographs on the surveys, and the answers to these arguments have been used to flesh out their various attempts to explain why the photographs look the way they do. Why did the chiefs of the expeditions earmark some of their hard-earned funds to pay and equip photographers in the field and then later, back in Washington, to pay for the production of photographic prints? One consistent and I believe mistaken answer has been that survey photographers were producing scientific "records," or were working in the discursive space of science/topography. These answers are aimed at showing that photographers like Bell and O'Sullivan were not working in the discursive space of modernist art—a claim so obvious that its mere enunciation provokes suspicion. It assumes a view of photography that was anything but current in the 1860s and 1870s: that it is inevitably or necessarily accurate, or accurate enough for the purposes of scientific representation. But this was not the view of scientists of the time and certainly not of Wheeler. Our comfort with the myth of contemporary science makes us fail to recognize that what we now think of as scientific practice is rather different from the quickly specializing American science of the survey decades. The entire complexion of scientific investigation changed rapidly in the 1880s, when the data collected and visualized by precision instruments effectively demoted descriptive science (which is what one part of the surveys did) and promoted a new discipline that was increasingly distanced from commonsense notions of observation and explanation. In his second published progress report, Wheeler writes:

I will also state some of the practical uses which may result from the application of the art of photography as an auxiliary in our interior surveys. It has been considered that the professional uses of photography, as an adjunct to a survey of this character, are few, so far comparatively little good beyond that which is of general interest as expressive of the scenic features of specified areas. The material data gathered from its use apply only to the departments of geology and natural history. In these departments, where, as is well understood, we are obliged to leave the field of

exact science, the special value that comes from a geological series of photographs results in the determination of a relative comprehension of the size and contour of the rock-beds and of the general features of the topography of the country. Should we, by the application of skilled labor and the refinement of instruments, be able to give a value to the horizontal and vertical measurements upon a photographic picture, at once the subject changes and an addition to positive data is gained.[12]

Wheeler's statements about photography leave no doubt that, like others in a position to appreciate the demands of exact science, he considers photography to be incapable of providing the kind of "material data" such science requires. Photography can serve as an auxiliary "to a survey of this character" but is, he argues, limited to subjects of "general interest" that represent or indicate "scenic features of specified areas." Wheeler understands (along with Clarence King) that photographs can only serve the needs of descriptive sciences like geology and natural history, and can only offer "relative" and not unqualified, positive data—the exquisitely quantified data provided by the precision instruments used, for example, in surveying, astronomy, and meteorology.

The final reports of the Wheeler expedition include a volume, written by Wheeler, titled *Geology* (vol. 3). The final reports of the King survey include a volume titled *Descriptive Geology* (vol. 2), coauthored by Samuel Emmons and Arnold Hague, King's geological assistants. King's own masterwork, *Systematic Geology* (vol. 1), attempted to move the study of geology away from the merely descriptive to the genuinely theoretic and comprehensive. In his review of the book in the *Nation*, Henry Adams insists on this point:

The most satisfactory part of Mr. King's work, next to its scientific thoroughness, is the breadth of view which embraces in one field the correlation of . . . extended forces, and the vigor of grasp with which the author handles so large a subject without allowing himself to be crushed by details. Hitherto every geological report has been a geological itinerary without generalization or arrangement. This volume is much more; it is, indeed, almost a systematic geology in itself, and might be printed in a cheaper form and used as a textbook in the technological schools.[13]

When Adams writes of past geological reports as being itineraries, what he means is that they provided summaries of the land traversed during the course of explorations. What they did not offer was an understanding of how any one given part of the land related to any other in terms of the enormous underlying forces that gave shape to the region under investigation. But Adams also notes the consequences of King's attempt to make geology into "a science in a new sense": it is a change of venue for geology, a transfer away from the general and the popular (as represented by the readership of the *Nation*) to the abstract and highly specialized. Adams notes that King's attempt to understand the enormous dislocations—elevations and depressions in the crust of the earth—along the route studied by the Fortieth Parallel survey requires resort to the field of terrestrial thermodynamics, "but it is far too technical to bear abbreviation, much less criticism, and we leave it to scientific periodicals to discuss."

For Wheeler, photographs could be used as part of the descriptive enterprise of the survey, to illustrate the outstanding geological features of the explored areas and to

depict ethnographic and botanical specimens. It did not take a special expertise conferred by a degree in science from Yale or four years of education at West Point to be able to spot "scenic features." But this effectively removes the exploration photographs from the discursive space of topography and precise science and places them back in a more humble and yet more promising setting—photographic practice in the 1860s and 1870s. Neither O'Sullivan nor Bell was trained as a scientist, and, as far as we know, neither was ever given remedial classes in geology or the other subject areas addressed by the surveys. And yet we know from the documents of both the King and Wheeler surveys that they were encouraged to work on their own—O'Sullivan photographed the Black Canyon of the Grand Canyon of the Colorado in 1871, on a "roving" and unsupervised "commission" from Wheeler—and Bell roamed freely at times during the field season of 1872.

Both King and Wheeler needed photographs, drawings, and paintings to illustrate the work of the expeditions. The final reports of both surveys include numerous lithographs modeled on pictures executed in all of these media. Those lithographs that were based on photographs, as far as I am aware, were never singled out by either King or Wheeler for their special scientific or photographic accuracy. Each of the surveys published albums of photographs and some carried "descriptive legends," in letterpress, of individual prints. The legend for plate 22 of the twenty-five print Wheeler survey album (1871–1874) reads as follows:

Descriptive LEGEND OF VIEW NO. 22

In the heart of our western territory are the Shoshone (Snake) Falls, a cataract which, in the height of its precipice and the grandeur of its surrounding scenery, is superior to Niagara, being excelled by the latter only in the width and volume of the river which falls. As yet this spot has been visited only by a few persons, such as explorers, miners, and soldiers; but without doubt it is destined to become, in time, a favorite place of summer resort for the tourist and artist. Its position is 110 miles northwest from Kelto, Utah, from which railway station a stage is dispatched daily to the settlements in Oregon and northern Idaho. The route of these stages passes within 8 miles of the falls, and, at the nearest point of approach, a rude station has been established at which the hardy traveler finds subsistence during his stay.

The accompanying picture affords excellent opportunity for the geological study of the cañon wall in the background, which rises perpendicularly 1,000 feet from the water. At the left of the view there will be observed a horizontal seam which cuts the cliff at an altitude of about 700 feet. This is the suture which marks the junction of the black basalt above and the greenish-blue trachyte underneath.

The legend reads like a passage from a commercially published tourist guidebook and was meant to. The comparison of Shoshone to Niagara sought to entice viewers whose interest in the romance of cataracts and falls was taken for granted. The inclusion of practical directions to reach the falls—take the railway to Kelto and from there take the stage to a point eight miles from the falls—suggests a trip that is, thanks to the railroad, a new and real possibility for those who could afford it. The addition of the last three sentences is a compressed return to geology and reads like an afterthought.

The legend for plate 23 of this same survey album (figure 3) begins on a geological note but ends with an invocation of the sublime.

Shoshone Falls, Snake River, Idaho T. H. O'Sullivan, Phot.

View Across top of the Falls

VIEW across the main or Horseshoe Falls.

So great has been the retrogression in the center of the river that the precipice has assumed a contour whose curve is almost semicircular. In the background, on the left, is a cascade of inferior size, which has been called Lace Falls. From upper level water to lower level water, or from the top of Lace Falls to the foot of Horseshoe Falls, there is a descent of 210 feet. The large fall has a perpendicular drop of 185 feet, 20 feet greater than Niagara. The stream is here about 800 feet wide and very deep, imprisoned in a cañon which is 1,000 feet in width and of equal depth, through which the river winds in lonely majesty, whose tranquility is disturbed at last by the plunge of this cataract, the roar of which is heard for miles away.

In the far background the black edge of the mesa rises in castellated form, in which the fanciful eye can find all the shapes of a fortress wall. Through this basalt the river washed its way long ago, and is now slowly deepening its channel in the underlying trachyte, the greenish hue of which lends a tinge to the shallow water in the foreground. There, on the brink of the abyss, surrounded by the stream and inaccessible to man, is seen a bare and dry point, half island and half promontory, which has received the name of Bald Rock.

The first paragraph of the legend is at odds with this dramatic, even threatening print, but the second paragraph, with its invocation of "the fanciful eye" and "the brink of the abyss" seems to surrender to it. O'Sullivan's use of a long lens eliminates any trace of the ground on which the camera was placed and the viewer is left suspended

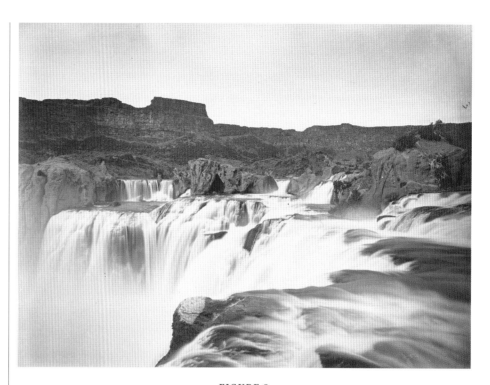

FIGURE 3

Timothy O'Sullivan, *Shoshone Falls, Snake River, Idaho, View across Top of the Falls*, 1874
Cat. 43

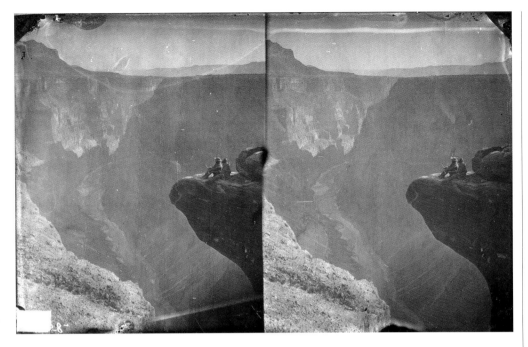

somewhere above the furious and cascading river. The long exposure resolves the water into juxtaposed fields of smooth grays and bubbling whites. The effect of the print is breathtaking. And the effect was part and parcel of why the photographs were made.

The albums of the Wheeler and King surveys were distributed to members of the legislature, to interested professionals, and to institutions and libraries. They promoted not only the surveys but also their chiefs. The scenic, ethnographic, archeological, mining, and botanical views used as the basis of illustrations for the interim and final reports were also employed for what we now call public relations. Understood from the vantage point of the two photographers, any given exposure could eventually serve a variety of needs.

I have been suggesting that the requirements of the surveys were multiple and often general and that O'Sullivan and Bell were aware of this. I have also argued that they were not scientific illustrators and that photography, in the period of the surveys, was not thought to be peculiarly or even more than marginally useful for a scientific program. But how then did the photographers approach their work in the field and what habits of work did they bring with them to their jobs? Alternatively, what part of their résumés or their careers made these two men attractive to the chiefs who employed them?

In the setting of a studio, photography was often, because of its unpredictability, a vexing occupation,[14] but outside, in the field, it could be maddening. It wasn't only that the photographer had to transport his camera and his darkroom into the field, risking breakage of plates, glass bottles,

and trays, or spilling crucial chemicals, but even when everything seemed to be working perfectly, the collodion process might simply and inexplicably refuse to work and it might take days to coax it back into line. Successful field photographers had backup plans for most contingencies and this generally required carrying far more in the way of chemicals and solutions than they would need in a studio. O'Sullivan had distinguished himself as a field photographer during the Civil War, creating well-known images of battlefields and scenic sites in captured southern territory. In late 1862, he was hired by Alexander Gardner, a photographer who had formerly been employed by Mathew Brady, to work in his new Washington studio. When Gardner received a contract from the Army to take charge of the production of urgently needed maps and copies of documents, he made O'Sullivan "Superintendent of the Field or Copy Work to the Army of the Potomac." The job required technical skills and the ability to make large numbers of prints in short periods of time. By the close of the war, O'Sullivan's reputation as a field photographer who could work under severe pressure was well known both within the Army and without. When Philp and Solomons published *Gardner's Sketchbook of the War*, a two-volume set containing one hundred photographs, O'Sullivan was responsible for the printing of thousands of photographs.

Bell began his career as a daguerreotypist in Philadelphia in 1848 at the age of eighteen and continued to work in a studio until 1862. At the close of the Civil War, he became the chief photographer of the Army Medical Museum in Washington, where he spent some years photographing soldiers who had recovered from severe battlefield injuries,

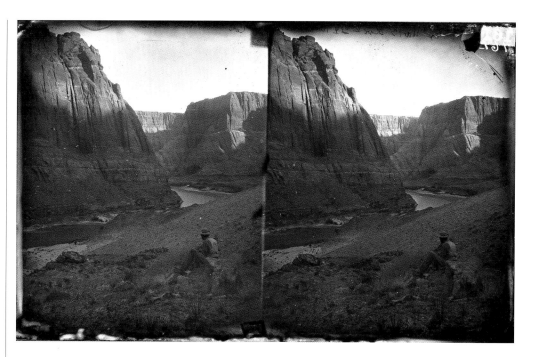

FIGURE 5
William Bell, *Panoramic—Canyon of Colorado and Paria*, 1872
Albumen print from stereographic negative
Photograph: National Archives and Records Administration

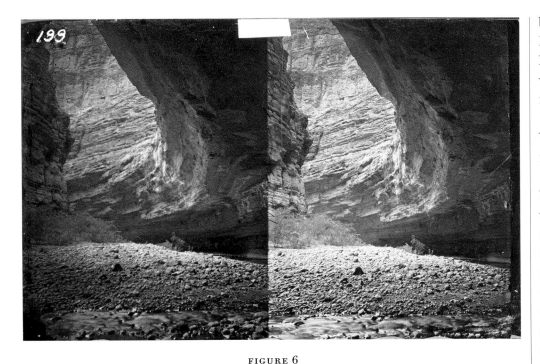

FIGURE 6

William Bell, *Kanab Wash, Colorado Basin
Canyon of Kanab Creek*, 1872
Albumen print from stereographic negative
Photograph: National Archives and Records Administration

but he also worked as a portrait and field photographer. Bell, like O'Sullivan, had established a solid reputation; he was also known for having successfully experimented with dry plate collodion photography, a very difficult-to-manipulate variant of the wet plate collodion process (see "Material Practices," pages 75–79). Bell, at the urging of Wheeler, made many if not all of his exposures during the field season of 1872 on collodion dry plates.[15]

In addition to the technical skill that O'Sullivan and Bell brought to the surveys, each also brought years of experience with a variety of studio practices and products. Each was familiar with a broad range of landscape photographs sold in studios—made locally and by photographers working in distant and often exotic locales. The understanding each man brought to survey photography had little to do with science but everything to do with making saleable stereographs and scenic views. The images made by O'Sullivan and Bell relied upon a knowledge of what kinds of photographs had been profitable items and what kinds failed to gain a market. And it would have been impossible for each of them to shed that knowledge.

The pictorial character of O'Sullivan's and Bell's photographs cannot be reduced to commercial formulae that were successful at the time they worked, but it is undeniable that each approached the work in the West with the habits, skills, and knowledge of commercial photographers—an approach that has not been carefully considered by art historians. Take for example the production of multiprint views made by both photographers. By 1872, the year Bell filled in for O'Sullivan on the Wheeler survey while O'Sullivan was on loan to King (and the fifth year of O'Sullivan's work for both

of the western expeditions), each man knew full well that there was no use for multiprint views by either of the chiefs. Yet O'Sullivan made them from time to time, and Bell made at least two in 1872. Where each of these photographers got the idea of producing these views, and why they spent the considerable energy it took to make them, is the subject of the essay that follows.

What then to say about the challenging pictorial character of these remarkable photographs produced by O'Sullivan and Bell for the western expeditions? There are some things we cannot say, though some authors have said them.[16] They cannot be accounted for by the invocation of the standby objective/subjective opposition—not at least if we wish to be faithful to the history of the distinction and the history of photography. Nowhere in the literature of photography of the times—from the most exalted treatises to the weekly and monthly babble in journals—is it possible to find any discussion of photography as a means of subjective expression. By and large, photographs were addressed as being the inevitable outcome of the agency of the sun. This is why camera men were called operators—they operated their cameras, but the sun was responsible for the picture. Nor is it possible to account for the odd juxtapositions, dislocations, or anti-picturesque elements of many of these images as the product of scientific "recording." I have suggested elsewhere that these photographs, from the point of view of the authors of the final reports and the chiefs of the expeditions, were useful not merely for the information they provided that was "expressive of the scenic features of specified areas," but also because many of the pictures do not fit well or easily into the standard tropes of

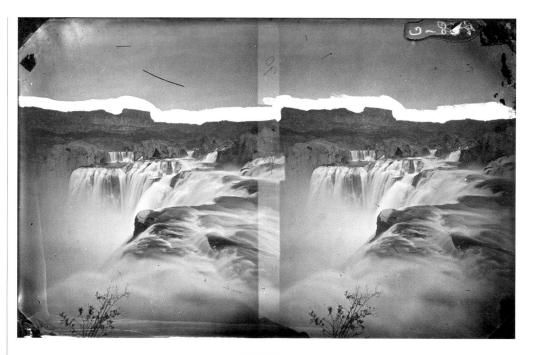

FIGURE 7
Timothy O'Sullivan, *Shoshone Falls*, 1874
Albumen print from stereographic negative
Photograph: National Archives and Records Administration

27

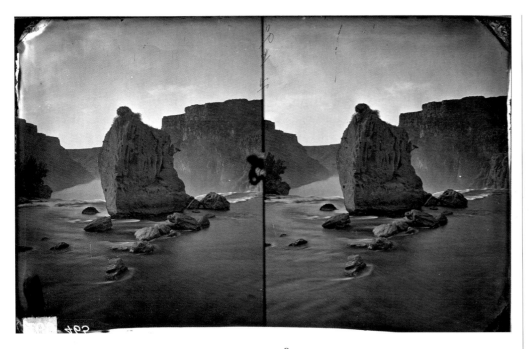

FIGURE 8

Timothy O'Sullivan, *Shoshone Falls*, 1874
Albumen print from stereographic negative
Photograph: National Archives and Records Administration

eastern landscape pictures. As such they are something akin to roadblocks.[17] They announced and often emphasized the difficulty of the western terrain and its lack of fit with the well-known, well-used, and comfortable formulae of landscape depiction routinely used by painters, sketchers, and photographers in the East. Other photographers, most notably William Henry Jackson, who worked for the Hayden survey, attempted to portray the American West as hospitable and inviting. For reasons we can only guess at, neither Bell nor O'Sullivan made photographs that strained to achieve picturesque effects, or labored to show the West as a comforting extension of the East.

NOTES

1. Some of the prints from this album, a duplicate Adams bought after donating the first to the Museum of Modern Art, are included in *One/Many*. They have been loaned by the Center for Creative Photography at the University of Arizona, which was established by a gift from Ansel and Virginia Adams. The title of the album is: *Photographs Showing Landscapes, Geological and Other Features of Portions of the Western Territory of the United States, Obtained in Connection with Geographical and Geological Explorations and Surveys West of the 100th Meridian Seasons of 1871, 1872, and 1873, 1st Lieut. Geo. M. Wheeler, Corps of Engineers, U.S. Army, in Charge.*

2. Newhall also included a second print by O'Sullivan, *Field where General Reynolds Fell* (1863), showing fallen soldiers on the battlefield at Gettysburg.

3. By the first decade of the twentieth century, all Civil War photographs—those published by Brady as well as by Brady's major competitor, Alexander Gardner—were routinely credited to Brady. These photographs included important pictures of major battlefields made by Timothy O'Sullivan.

4. I mean "innocent" here in much the same sense intended by Mark Twain in his 1869 classic, *Innocents Abroad*, that is, unsophisticated, uncultivated, unspoiled, honest, direct.

5. Newhall's 1937 exhibition was indebted to two European precursors, one in Stuttgart in 1929, and the other in Paris in 1936.

6. From 1929 through 1946, Stieglitz ran a gallery called An American Place. In a statement written for an exhibition of his work at the Anderson Gallery in 1921, Stieglitz provided this self-dramatizing credo: "I was born in Hoboken. I am an American. Photography is my passion. The search for truth my obsession."

7. The growth of the population in the interior of the western territories was rapid, but the growth of the entire region was extraordinary. The western population as a whole spiked from roughly two million in 1850 to seven million by 1870. The resulting pressure on the native population was immense and led directly to the tragic and decisive military actions that forced native tribes onto reservations and effectively brought an end to their independence.

8. O'Sullivan worked for the Isthmus of Darien expedition in 1870.

9. Clarence King, *Systematic Geology*, Professional Papers of the Engineer Department, U.S. Army (Washington, D.C.: U.S. Government Printing Office, 1878), p. 1. Although *Systematic Geology* was listed as volume one of the final reports, it was the last of the seven volumes to be published.

10. The economic motive for the surveys was well recognized at the time, but was not treated as the sole or overriding goal of the expeditions. An early review of the first published volume of the Fortieth Parallel survey allows that "the public" is "most generally interested" in matters of "dollars and cents," but makes it clear that the various goals of the surveys are hardly limited by the general interest of the public and implies that the forthcoming volumes will have a different audience.

> *United States Geological Exploration of the Fortieth Parallel*, by Clarence King, Geologist in Charge.
>
> *Mining Industry*, by James D. Hague; *with Geological Contributions* by Clarence King. Submitted to the Chief of Engineers and published by Order of the Secretary of War under Authority of Congress. Illustrated by Thirty-seven Plates and accompanying Atlas. Washington: Government Printing Office, 4to., pp 647, 1870.
>
> This, as we are informed in a prefatory note, is the *third* volume in the series of the "Geological Exploration of the Fortieth Parallel," although the first in the order of publication; first, because most generally interesting to the public, which looks first at questions of dollars and cents, and first, also, because, being something of a monograph in its character, it could be readily finished up at once, without waiting for the final results of the whole exploration. The other volumes of the series, four in number, are to be as follows I., Systematic Geology; II., Descriptive Geology; IV., Zoölogy and Palaeontology; V., Botany.

"Book Reviews," *North American Review* 113, no. 232 (July 1871): 203-204.

11. "Scientific Intelligence," *Harper's Weekly*, May 6, 1871, 403.

12. George M. Wheeler, "Photography—Miscellaneous," *Progress-Report upon Geographical and Geological Explorations and Surveys West of the One Hundredth Meridian, in 1872, under the Direction of Brig. Gen. A. A. Humphreys, Chief of Engineers, United States Army, by First Lieut. George M. Wheeler, Corps of Engineers, in Charge* (Washington, D.C.: U.S. Government Printing Office, 1874), 11.

13. Henry Adams, "King's Systematic Geology," *Nation* 28, no. 708 (1879): 73-74.

14. See one photographer's complaint: "The Total Depravity and Gymnastics of Inanimate Things Photographic," *Philadelphia Photographer* 2, no. 22 (October 1865): 155-57.

15. See Wheeler, "Photography—Miscellaneous," 12.

16. I am as guilty as any author on this count. See my *American Frontiers: The Photographs of Timothy H. O'Sullivan, 1867-1874* (New York: Aperture, 1981).

17. Joel Snyder, "Territorial Photography," in *Landscape and Power*, ed. W. J. T. Mitchell (Chicago: University of Chicago Press, 1991), 200.

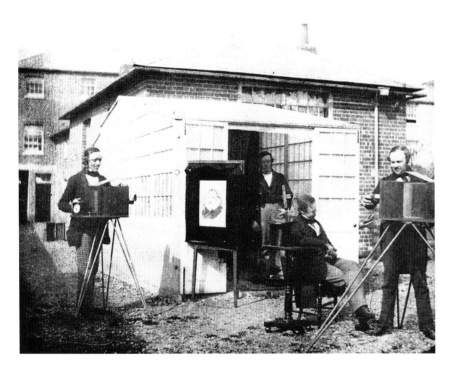

William Henry Fox Talbot and Nicolaas Henneman,
The Reading Establishment, ca. 1846
Salted paper prints from calotype negatives

JOEL SNYDER

Photographic Panoramas and Views

THE PRODUCTION OF PHOTOGRAPHIC PICTURES showing a broad, encompassing view at one glance began in the first decade of photographic practice. William Henry Fox Talbot and the painter/photographer Richard Calvert Jones created panoramic views made of two or more conjoined prints (so-called panoramic joiners) from paper negatives in the mid-1840s (figure 9). In 1847 the German-born printmaker and photographer Frederich von Martens, who exhibited his engraved views of European cities at the Salon from 1834 to 1848, invented the Megaskop-Kamera or Panorama-Kamera, which was capable of producing a single, oblong daguerreotype showing a 150-degree angle of view (figure 10). Photographers were taking their lead from printmakers in the older graphic arts who had long published single-sheet views (including the bird's-eye variety) of well-known cities, fold-out prints of city- and landscapes sewn into books, and long, flat prints for sale at stationer and print shops. The term "panorama" when applied to prints is not terribly specific. Although it first appears in 1787 as the name for the spectacular presentation of an enormous painting, the term was rapidly incorporated

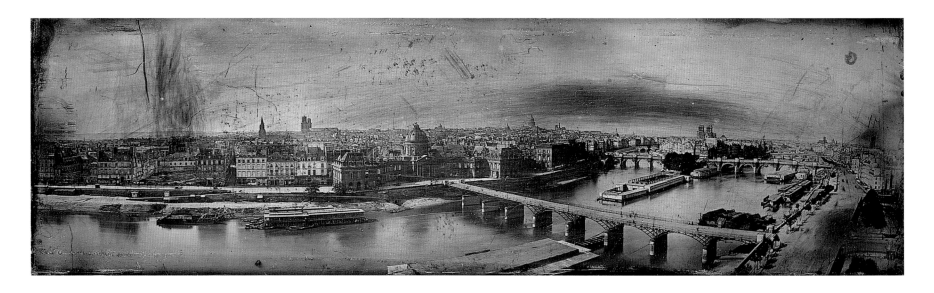

FIGURE 10

Frederich von Martens,
Vue de Paris, ca. 1847
Daguerreotype
Photograph: Société Française
de Photographie

FIGURE 11

Julius Bien, after John Bachman,
Panorama of New York and Vicinity, 1866
Lithograph

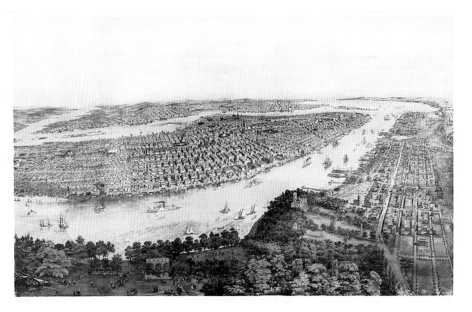

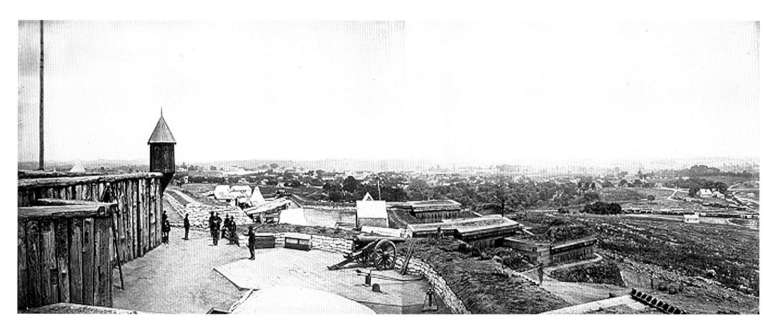

FIGURE 12

George N. Barnard, *From Fort Negley, Nashville, Tenn., March 1864, Looking North East*, 1864
Albumen print
Photograph: Library of Congress

into the printmaker's glossary and came to be applied not only to long, continuous or multisectioned prints, but to not particularly large prints that we might think of today as "wide-angle" views (figure 11).

The photographic equivalents of these lithographed and engraved panoramic views of cities and landscapes often took the form of single-plate pictures of well-known tourist attractions like Niagara Falls. They were also made in the form of carefully spliced-together multiple prints mounted to a durable canvas backing. George Barnard created multiplate views for General William Tecumseh Sherman's Army of Tennessee that had little military utility but great memorial value (figure 12). The general public could also buy, in this period and well into the twentieth century, stunning multiplate views of recent disasters having a national importance (figure 13).

Lithographed or engraved general views of notable European cities had long been made for exhibition in salons

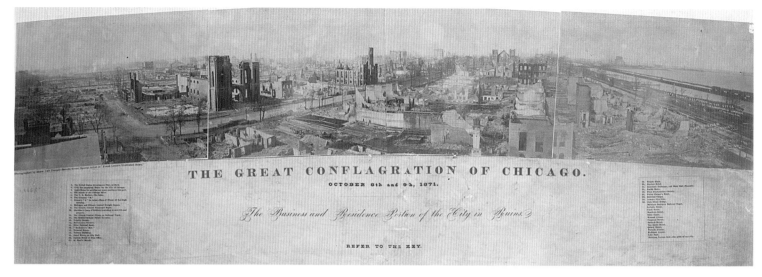

FIGURE 13

William Shaw, *The Great Conflagration of Chicago. October 8th and 9th, 1871*, 1871
Albumen print
Photograph: Library of Congress

and for domestic display. This habit was echoed in American photographers' creation of large multiple-plate views of cities such as New York, Boston, Philadelphia, Washington, D.C., and San Francisco. This practice was quickly adopted by photographers in smaller towns throughout the country who sold their images to local citizens and civic boosters, but who were especially interested in finding a broader market by focusing attention on some remarkable feature of their hometowns. The four-plate view of Cincinnati dating from 1866 (figure 2), for example, was intended to highlight the modern character of the city (then the largest in the Midwest) by showing its riverfront and a small portion of

the world's longest suspension bridge. Designed by John Augustus Roebling, the bridge was a marvel of modern engineering; it kept the title of world's longest until surpassed in 1883 by Roebling's Brooklyn Bridge. The practice of making such multiple-plate views extended to the smallest and newest of towns, even where no remarkable civic feature called out for memorializing (see figure 14).

By the time the federal government began funding the large-scale explorations of the American West in 1867, the custom of making and selling photographic views and multiple-plate panoramas was well established, and, unremarkably, the expeditionary photographers brought these skills to

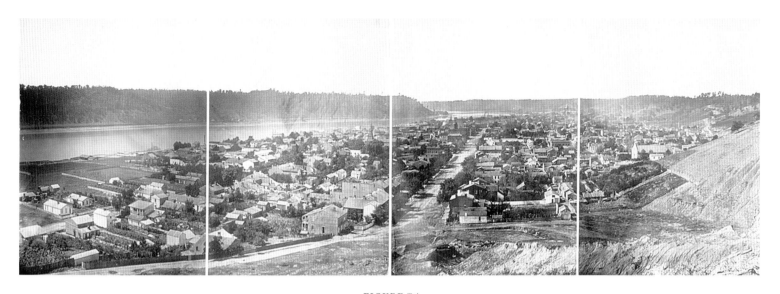

FIGURE 14

Photographer unknown, *Madison, Indiana,* ca. 1870
Albumen prints from collodion negatives

their work in the West. One major task of these photographers was to make pictures that would serve as models for the lithographs that were to be integral to the surveys' various reports. Another charge was to produce arresting photographic prints and stereographic cards (see figures 4–8) that might serve to educate and entertain congressmen and others associated with the federal government who could directly or indirectly influence the funding of the surveys.

Both Timothy O'Sullivan and William Bell made a handful of multiple-plate panoramas as part of their survey work. Given the difficulty of producing them under trying circumstances, it is remarkable that only one, *Beaver Park, Valley of Conejos River, Colorado,* was later converted into a lithograph and presented in a survey publication (figure 15). So far as is known, only three of O'Sullivan's and Bell's remarkable multiplate panoramic views of the West were ever printed and mounted for exhibition. These three, one by O'Sullivan and two by Bell, were shown in the War Department exhibit at the Philadelphia Centennial Exposition in 1876. They were mounted within yards of an exhibit of George Washington's Valley Forge camp gear and not very far from a display of rifles made by the Army Arsenal and Gatling guns manufactured by Colt. The exhibition of the Bell multiplate views in *One/Many* is, in all likelihood

VOL.I GEOGRAPHICAL REPORT. U.S. GEOGRAPHICAL SURVEYS WEST OF 100TH MERIDIAN PLATE XIII

BEAVER PARK VALLEY OF CONEJOS RIVER, COLORADO

FIGURE 15

After Timothy O'Sullivan, *Beaver Park, Valley of Conejos River, Colorado*, 1874
Cat. 69

and at most, only the second time either has been shown in public (see figures 18–20).

In light of this history of use, the Bell and O'Sullivan panoramas would seem to be something of a mystery. Considering the brief and meager history of their publication, why were they made at all? This question makes sense only if we assume that the photographers and their superiors knew in advance not merely the general use that would be assigned to all the photographs, but the specifics of how they would be deployed as illustrations and how any given photograph would be used in the various survey publications. The collecting of data and materials (including photographs) for the reports was a task that was undertaken and accomplished without a well-formulated plan for their presentation. Accordingly, a two-plate panorama could serve as the basis for a double-page lithograph, while one of its constitutive parts could function as a solo illustration in an album of Wheeler photographs.

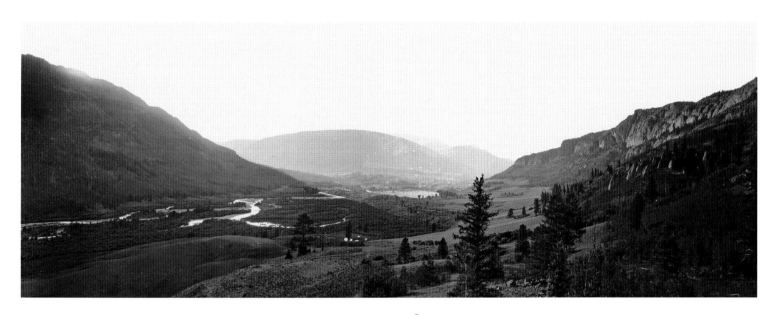

FIGURE 16

Timothy O'Sullivan, *Beaver Park, Valley of Conejos River, Colorado*, 1874
Digitized reconstruction of two-plate panorama

And in fact, one of the photographs that constitutes the left side of O'Sullivan's *Beaver Park, Valley of Conejos River, Colorado* (figure 16) also appears as an individual plate (figure 17) in the Wheeler "Photographs" album of the field seasons of 1871–1874.[1]

Bell made at least two multiple-plate views during the field season of 1872. Wheeler might well have thought that panoramas of the Grand Canyon of the Colorado would be particularly useful in the ongoing drive to obtain continuing funds for his expedition, or he might have hoped that he could illustrate one of the final reports by means of a long fold-out panoramic lithograph of the canyon. The Grand Canyon was, after all, a subject of great popular interest, and Wheeler devoted much time and energy (as it turned out, somewhat foolishly) repeating in 1871 John Wesley Powell's navigation of a part of the Colorado River that courses through the canyon. He returned to the canyon again in 1872.

Bell's six-plate panorama, *Grand Canyon, Colorado River, Arizona* (figures 18 and 19), shows the view from Vulcan's Throne near Toroweap, looking south and west.[2] Taken a few steps back from the near edge of the canyon, the

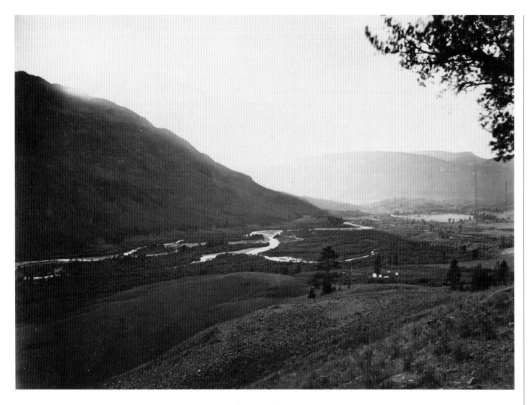

FIGURE 17

Timothy O'Sullivan, *View near Head of Conejos River, Colorado*, 1874
Cat. 45

image presents both foreground and the distant canyon wall. It hints at but does not show the valley floor. It suggests far more than it can possibly show—a barren, immense spectacle—and shows it in spectacular form. The panorama does not strain for effect. Like the multiplate panoramas of cities and towns, it reveals what lies straight ahead, out in front of the camera. Unlike these views, it also suggests something not merely about the exotic, but about the amount of sheer human effort, energy, and exhaustion that was required to make it.

NOTES

1. *Photographs Showing Landscapes, Geological and Other Features of Portions of the Western Territory of the United States, Obtained in Connection with Geographical and Geological Explorations and Surveys West of the 100th Meridian Seasons of 1871, 1872, and 1873, 1st Lieut. Geo. M. Wheeler, Corps of Engineers, U.S. Army, in Charge.*
2. I am indebted to the photographer Mark Klett for his identification of the location and direction of the view.

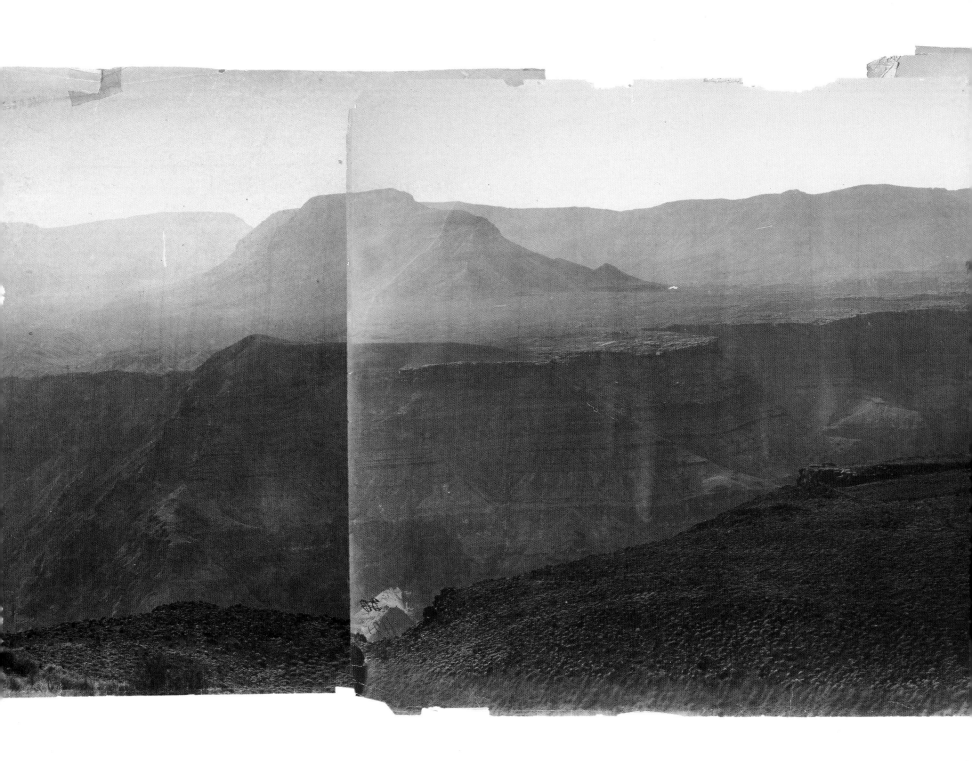

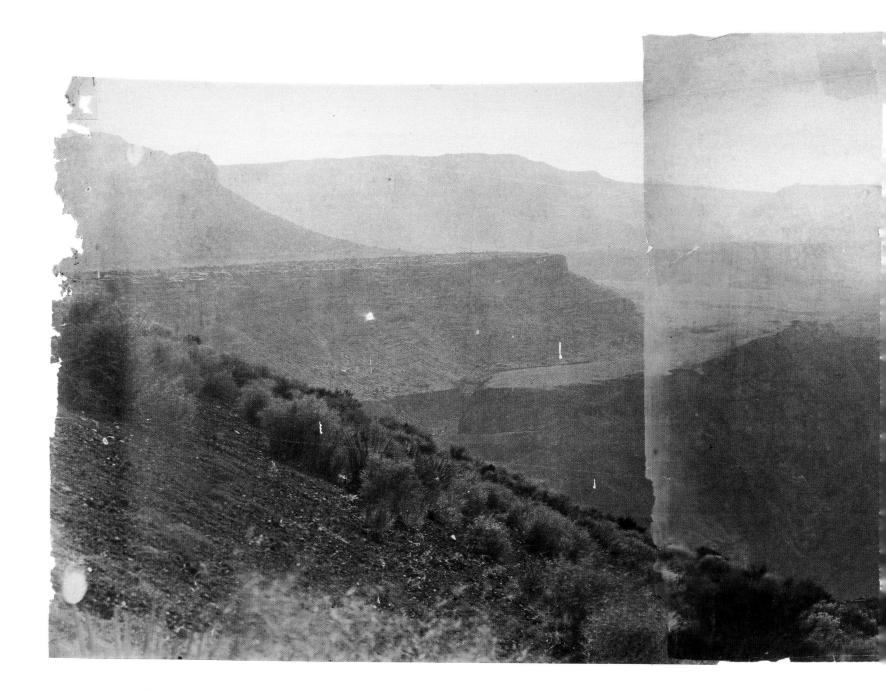

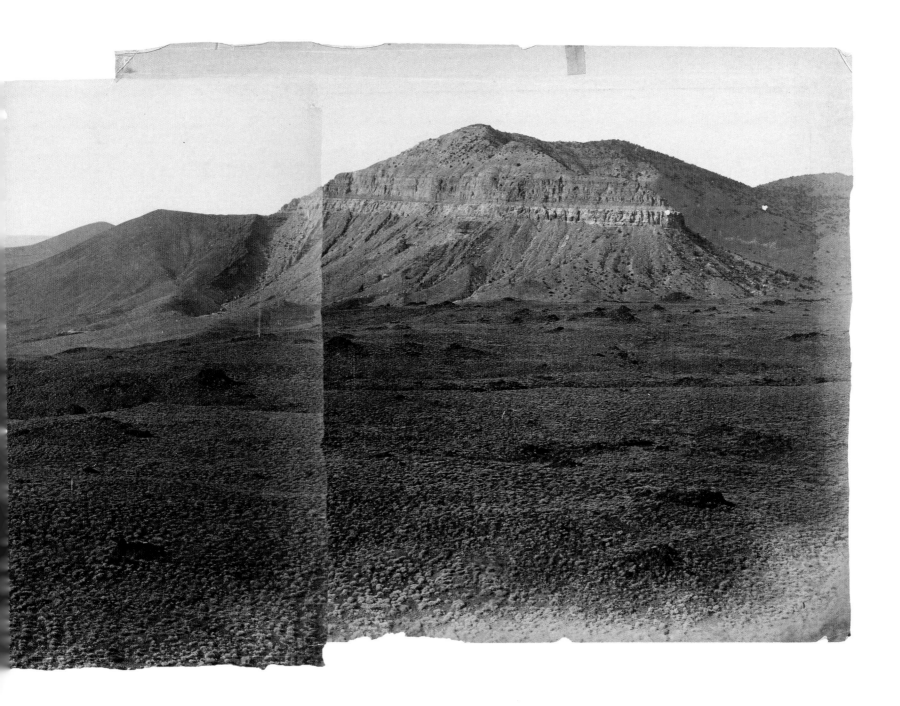

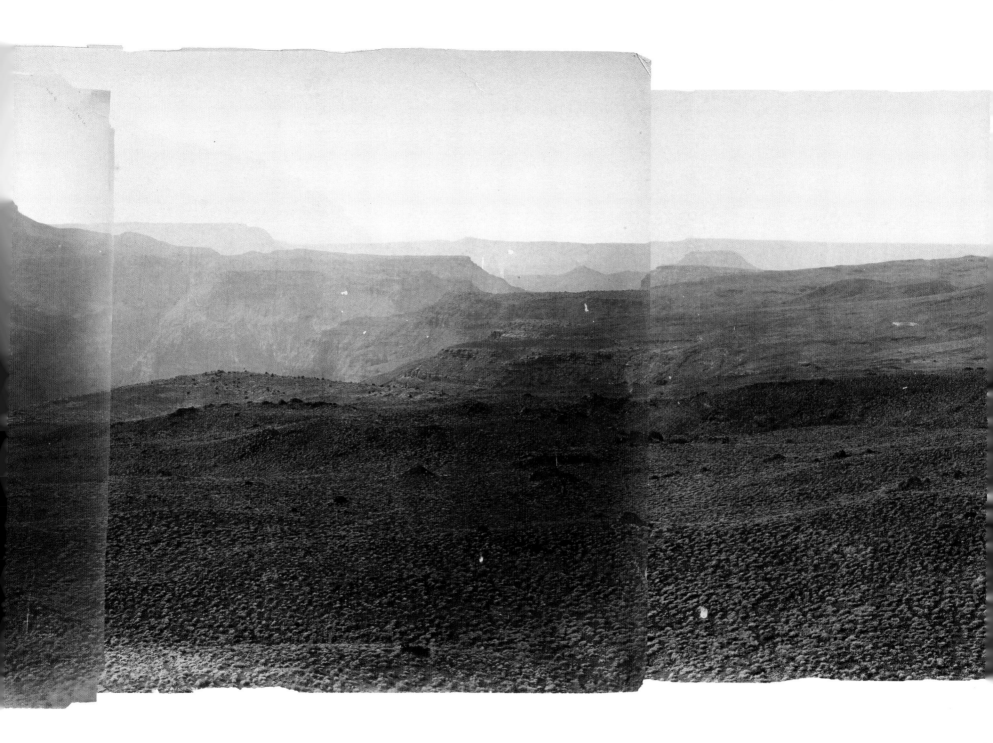

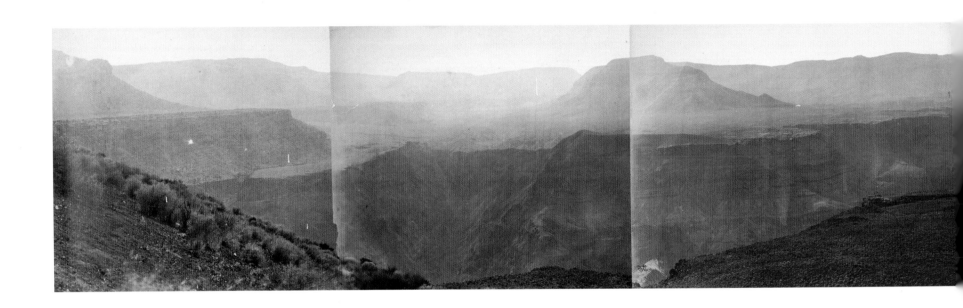

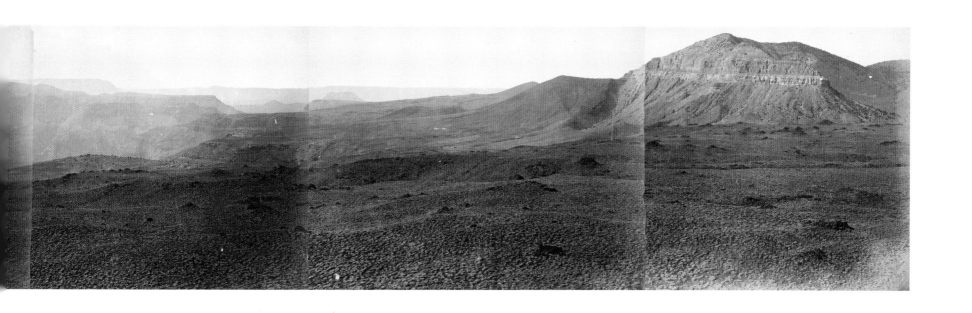

FIGURE 19

Cropped version of figure 18

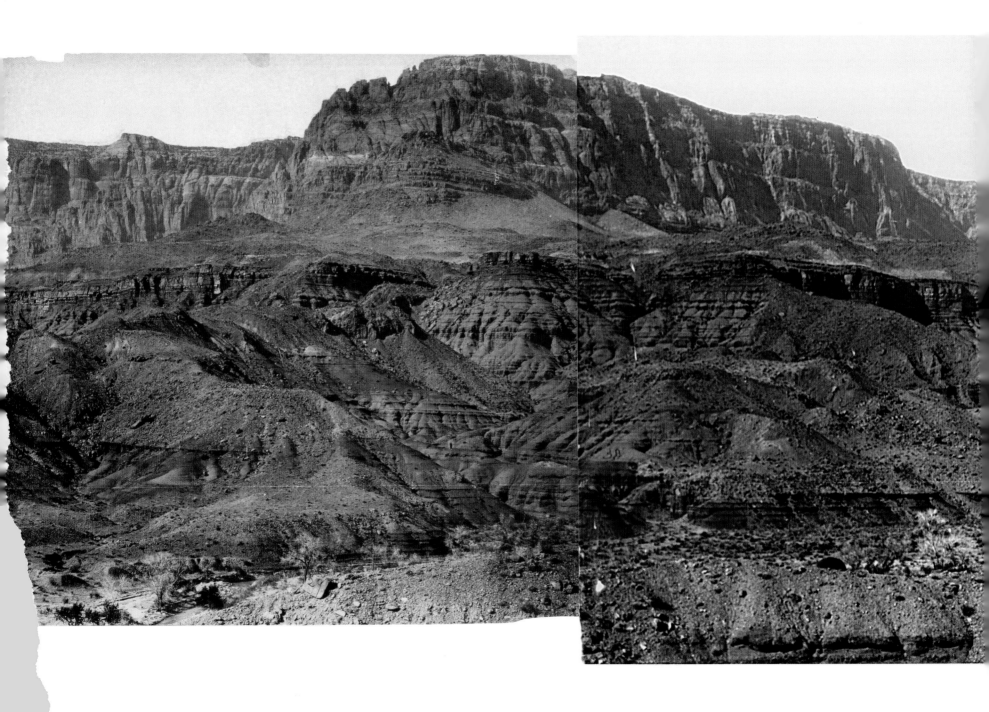

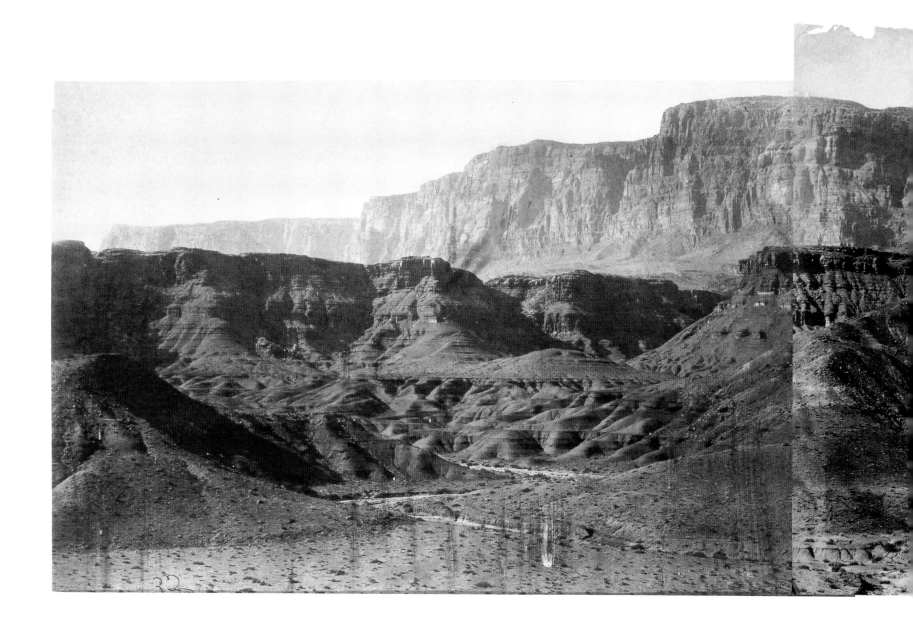

FIGURE 20

William Bell, *Canyon and Headlands
of Colorado and Paria Rivers*
(beneath the Vermilion Cliffs), 1872
Panorama; four albumen prints and one
modern print from original negative
Cat. 46a–e

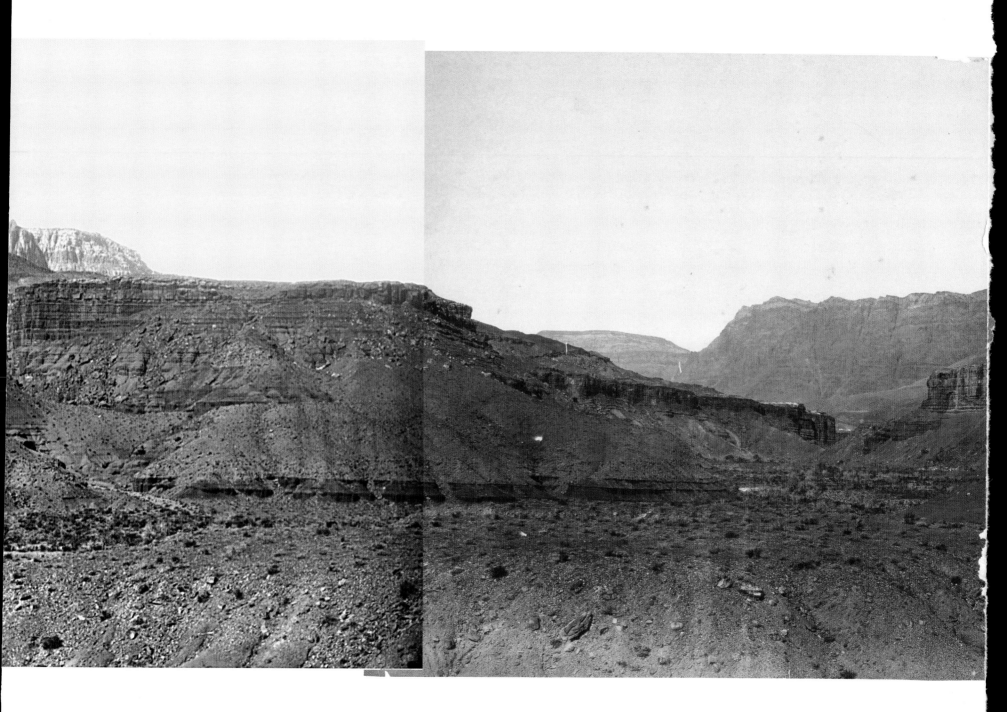

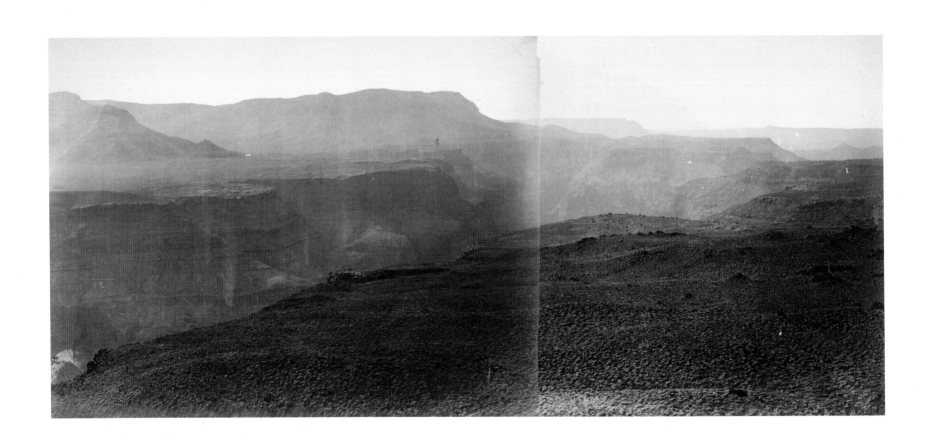

JOSH ELLENBOGEN

Inhuman Sight: Photographs and Panoramas in the Nineteenth Century

BY THE TIME TIMOTHY O'SULLIVAN AND WILLIAM BELL turned to panoramic photography in the years around 1870, both photographs and panoramic paintings were established representational forms and the objects of developed critical discussions.[1] Of the various claims observers made about these two types of picture, none was more central to attempts at their definition, more complex and ambiguous, or more significant to understanding the relations between the photograph and the panorama, than accounts of how the two sorts of image addressed the world we see. As a result, discussions of how these pictures relate to the visual world must play a central role if we are to grasp the importance of panoramic photographs within the King and Wheeler geological surveys. How did nineteenth-century observers construe the terms of overlap between photographic and panoramic representation?[2] What tasks could the survey heads, as well as Bell and O'Sullivan, have imagined these striking pictures could accomplish?

In 1867, the same year in which King embarked on his first survey, the English essayist H. J. Stack opined of photo-

Cat. 49c–d

graphy that, while "it is generally supposed that photography comes to us with something like a perfection of imitative capacity," in reality "this is not the case." Stack took such a position because, when we consider the characteristic ways in which photography represents the world, the kind of focus it imparts to its objects and the way it registers light, the results "will never be found conformable . . . to the impressions which, through the eye, the scene depicted makes upon the mind."[3] Stack's argument, which emphasizes the discrepancy between what the eye sees and what the photograph shows, is not at all unusual in nineteenth-century discussions of photography. Commentators routinely insisted on the lack of fit between the photographic document and ocular experience, basing what would become some of the most famous discussions of the medium partly on this insight.[4]

Yet, sometimes in the same breath, those who made such pronouncements often asserted that photography enjoyed a kind of privilege, either in depicting particular aspects of the visual world, or in making documents of it that would be well-suited to specific employments, or in providing a record of certain types of visual information, or even in corresponding to particular modes of human perception. Of course, those who insisted on a discrepancy between the eye's experience and the photographic document at that time did so for varied reasons, and they came to different conclusions. For the present discussion, Oliver Wendell Holmes's understanding of the matter is particularly valuable.[5] Not only was Holmes the most acute American essayist on photography in the 1850s and 1860s, but he developed his understanding of the medium while looking

at Civil War photographs issued by Alexander Gardner, for whom O'Sullivan himself worked during the war.

Human Perception and Photographic Vision

A good entry-point to Holmes's thinking on photography comes from the conclusion to his 1859 essay "The Stereoscope and the Stereograph," in which he attempts to weigh the importance and future of photographic technology. Holmes states, in considering the effects of photography, "*Form is henceforth divorced from matter*," adding "In fact, matter as a visible object is of no great use any longer, except as the mould on which form is shaped."[6] By "form," Holmes means the visual appearance of objects. In stating that visual appearance has become divorced from matter in photography, Holmes means to emphasize what he views as one of the most marvelous capacities of the medium—its ability to disrupt normal causal relations. That is, "Under the action of light . . . a body makes its superficial aspect potentially present at a distance, becoming appreciable as a shadow or a picture. But remove the cause,—the body itself,—and the effect is removed."[7] In the absence of the material body that throws off the formal picture, the picture should vanish, and historically it has done so. Photography, however, allows the pictures to persist in time, outlasting the causal matter to which they have been yoked. Once a photographer takes the image of a man, that image remains even when the man leaves the room, or goes off to war, or dies in battle.

I have suggested that bodies "throw off" pictures in the above, because Holmes, if at least partly in jest, believes photography compels him to return to ancient Greek accounts of vision. Although we must not assume that Holmes, a

practicing physician who carried out research on the functioning of the retina, thinks such descriptions amount to valid explanations of what actually happens in vision, he nonetheless refers to such thinkers as Democritus of Abdera. According to Holmes, Democritus's explanation of vision rests on the argument that "all bodies were continually throwing off certain images like themselves, which subtile [*sic*] emanations, striking on our bodily organs, gave rise to our sensations." Holmes adds, "Forms, effigies, membranes or *films*, are the nearest representatives of the terms applied to these effluences."[8] In Holmes's discussion, these films thrown off by objects emerge as pictorial, in that one can treat a photographic portrait as being one such film, frozen and fixed in place.

The idea that pictorial "films" shed by objects exist independently of observers and lodge themselves in the eye or on a photo-sensitized plate clearly helps Holmes think out certain problems posed by photography. On the one hand, the mere fact we can make a photograph probably makes the older discussion seem attractive. Because the pictures of objects we get in photographs do, in certain ways, resemble the pictures we see, the fact that the former pictures have independent existence may lead Holmes to play with the suggestion that the latter images do as well. On the other hand, and this matter makes insistent the question of discrepancy between photographs and vision, Holmes is equally aware of how photographs do not resemble what we see. That is, Holmes probably chooses to pick up the idea of a pictorial film that exists apart from human observers owing to the photograph's capacity to show things that they eye does not discern. By the 1860s, photographs had come

into circulation that Holmes believed showed us things we simply do not see by eye.[9] As a result, the idea that there are autonomous pictures that exist beyond observers, some of which their eyes capture and some of which they do not, began to look like a potentially instructive model to Holmes. Because the photograph can detect those pictures that are beyond the eye, its divergence with vision partly lies here, and we need to consider this matter carefully.

We can get a sense of the divergence between photography and visual experience when we consider the example of objects that move or that display change through time. Let's take the example of a friend's face, someone we know well and with whom we are on intimate terms. Because we live in a photographic era, we can assume this friend will be photographed "every few years or months or days."[10] Thinking of the serial images that issue from this regular cycle, Holmes claims the following about photography:

> By and by it will show every aspect of life in the same individual, from the earliest week to the last year of senility. We are beginning to see what it will reveal. Children grow into beauty and out of it. The first line in the forehead, the first streak in the hair are chronicled without malice, but without extenuation. The footprints of thought, of passion, of purpose are all treasured in these fossilized shadows. Family-traits show themselves in early infancy, die out, and reappear. Flitting moods which have escaped one pencil of sunbeams are caught by another. Each new picture gives us a new aspect of our friend; we find he had not one face, but many.[11]

Holmes makes similar claims about other displays of alteration through time. For example, in considering the phe-

Fig. 3.

FIGURE 21

Drawing after
photograph of
walking man
From Oliver Wendell
Holmes, "The
Human Wheel, Its
Spokes and Felloes,"
*Soundings from the
Atlantic* (Boston:
Ticknor and Fields,
1864), fig. 3

nomenon of human locomotion—what happens when a person passes before us—he comments on the difference between seeing the motion by eye and viewing it in a photograph in a way that seems almost appropriate to Muybridge or Marey.[12] The camera captures postures and positions that we never see in perception, tendering previously unknown information about the mechanism of the human walk. The information contained in such photographs, Holmes believes, could be usefully incorporated into the design of artificial limbs, a question that had become topical in 1863 owing to the great number of war amputees (figure 21). So alien are the postures the camera discloses to the eye's impression of a walk that Holmes writes: "No artist would have dared to draw a walking figure in attitudes like some of these."[13] By the terms of Holmes's argument, we cannot simply assimilate photographic images to the ones that make up our perception of the world.

The specific nature of the discrepancy between vision and photography emerges in such statements as "he had not one face, but many." Put another way, photography's orientation to multiplicity, the "many" in this statement, gives it a status as a kind of total representation that departs from the partial and selective views we have in perception. For Holmes, the human experience of an object centers on attention and selection. We see that this is the case in regard to the hypothetical friend of whom we have gathered a series of photographs. Because the fact that "he had not one face, but many" comes as news to us, it is evident that, in knowing this person and seeing the changing array of expressions and aspects his face offers us, we come to seize upon one expression or aspect and make it stand for the

series, while the greater part drop out of our experience. We do not see them, which is why the series of photographs comes to be revelatory.

Something similar appears to be happening in the case of human locomotion. Holmes believes that we have always had an imperfect idea of what really goes on when a person walks before us—many of the postures the camera discloses are ones of which we are never aware. Yet, we have always tricked ourselves into believing that we did have a complete understanding of the facts of walking, so that we would even have been comfortable dismissing the work of a painter that departed from what we thought we knew. That is, we took a few postures from the complicated series and made these represent the whole.[14] Photography's importance for Holmes, in the case of either the changing expressions of the friend or the changing positions of the walking person, centers on its ability to give us access to the totality of the series, without the selection that inflects human seeing.

If this account of Holmes's position works, we can begin to characterize what the photograph provides, namely, a total presentation of the object. It reveals every possible center of attention, be it every changing aspect of the object through time or every potential focus within the object at one moment. In this sense, we can say that it presents to us the "outer appearance" of objects prior to their having been perceived.[15] Following Holmes's example, without believing in ancient Greek accounts of vision, we can treat the accounts as useful to think with and say the picture that lodges in the eye undergoes certain treatments. The treatments make the picture different from the one that lodges itself on a photographic plate.

Holmes's characterization of the photograph as standing prior to perception allows him to differentiate it from painting on the basis that:

> You can find nothing [in a painting] which the artist has not seen before you; but in a perfect photograph there will be as many beauties lurking, unobserved, as there are flowers that blush unseen in forests and meadows. It is a mistake to suppose one knows a stereoscopic picture when he has studied it a hundred times by the aid of the best of our common instruments. Do we know all that there is in a landscape by looking out at it from our parlor windows?[16]

Holmes's invocation of "common instruments" points to certain spectatorial habits that the photograph's status warrants: the use of magnifying glasses and low-power microscopes. Because the photograph catches without alteration the picture that objects throw off, it makes sense to appraise photographs by means of such devices, just as one might direct a telescope at an actual landscape.[17] On the other hand, as a general rule, it does not make any sense to view a painting through opera glasses or binoculars.

A pair of images may make these matters clearer. Joel Snyder has elsewhere pointed out that a photograph such as O'Sullivan's 1863 shot *A Harvest of Death, Gettysburg, Pennsylvania* (figure 22) should be seen as anomalous within the context of mid-nineteenth-century photography because it holds one object that is clearly the center of the picture.[18] Rather than putting every plane equally into focus, giving everything the same weight, presenting every possible source of meaning and center of attention, this photograph depicts the body in the foreground so that a selection already

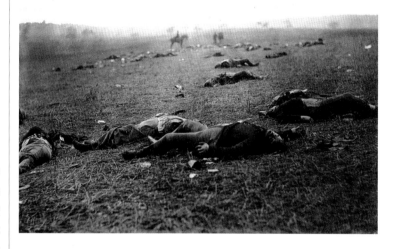

FIGURE 22
Timothy O'Sullivan, *A Harvest of Death,
Gettysburg, Pennsylvania*, July 1863
Photograph: George Eastman House

appears to have been made. Plugging this formal insight into the argument I have already sketched out, we can say that this image presents the scene as though it were an object of perception, as if the "outward appearance" it offered was being seen by a person.

In this way, the image departs from *Culpeper, Virginia*, another 1863 image by O'Sullivan (figure 23). Photographs such as this one make little effort to supply a center, and present the world "without any humanizing help of the hand of the artist."[19] Because the photograph contains in

FIGURE 23
Timothy O'Sullivan, *Culpeper, Virginia*, November 1863
Photograph: George Eastman House

itself all potential centers of interest that an observer might see in visual experience, to look at the photograph is the same as looking at the material object, with the infinity of pictures that object offers. To look at a collection of photographs of famous places is "to visit them all, as tourists visit the realities."[20] It is not the same thing as hearing the spoken account of someone who visited the place, or looking at a painting meant to be a record of an individual's visit, because such records, owing to the nature of perception, are necessarily partial: "Tourists cannot be trusted; stereographs can."[21]

Significantly, contemporary observers made the same point in regard to ersatz travel and panoramas. As one example, a reporter for the St. Louis *Weekly Reveille* maintained in 1850 that the panorama was a "wonderful invention for annihilating time and space" because "the necessity of taking long sea voyages for the recovery of health, or short trips for purposes of pleasure, has been superceded [*sic*] by the modern introduction of panoramas."[22] That is, a part of the overlap between photographs and panoramas consists in the way they obviate the need for actual travel because of the relationship between them and their originals. A panoramic painting of a western emigration route would make an observer "actually believe he was on his way to California."[23] In considering the overlap between photography and panoramas, above all in regard to views of the West, one might also consider the comments that critics directed at Robert Vance's 1851 exhibition of his daguerreotypes in New York. Entitled *Views in California*, this show has special significance to the present discussion, in that it represents one of the earliest efforts to make photographic records of the West. According to the *Photographic Art Journal* of October 1851, "this collection [of daguerreotypes] comprises a complete panorama of the most interesting scenery in California" and "there are over three hundred daguerreotypes so arranged that a circuit of several miles of scenery can be seen at a glance."[24] The second part of this citation particularly underscores the resonance between certain nineteenth-century conceptions of photography and panoramas. The original name of panoramic painting, in fact, was "nature at a glance" [*la nature à coup d'oeil*].[25]

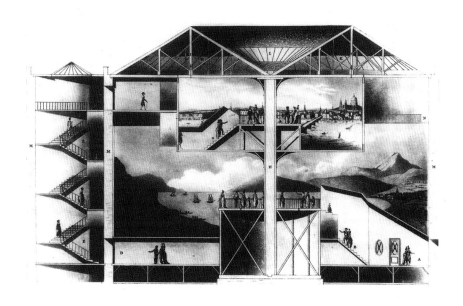

FIGURE 24

Cross-section of panorama
From Robert Mitchell, *Plans and Views in Perspective*
(London: Wilson and Co., 1801)

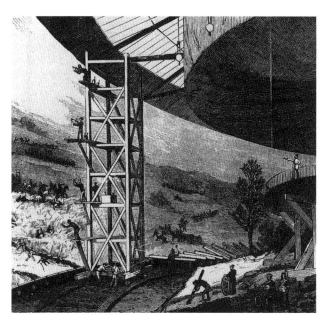

FIGURE 25

Interior view of panorama shortly before completion
From Albert Hopkins, *Magic, Stage Illusions, and Scientific Diversions*
(New York: Munns, 1898)

But what can it mean to suggest that a series of photographs, or even a single one, shows anything at all "at a glance"? If such pictures did show objects at a glance, with all the connotations of the casual and the hasty and unsystematic that glancing carries with it, why would such images be worthy of receiving attention through a microscope or magnifying glass? In order to address this question, we should briefly turn to the history and practice of panoramic painting. By mid-century, distinct kinds of panoramas had come into being, from the original, classic style of panorama (also called a "cyclorama"), to the diorama, to the moving panorama.[26]

If we consider the original kind of panoramic painting Robert Barker presented to the world in 1787, it is as difficult to understand how it relates to seeing "at a glance" as is the case for photography. Such panoramas provided a 360-degree representation, "A picture of a landscape or other scene . . . arranged on the inside of a cylindrical surface round the spectator as a centre (a cyclorama)."[27] The painting often depicted a landscape or cityscape from an identified

promontory, or might picture a famous event in the news of the day.[28] The audience would enter the building that housed the panorama painting through a darkened hall, surfacing onto a viewing platform where the panorama that awaited them appeared brilliantly illuminated, as if it contained the full light of day (figures 24 and 25). In the most elaborate panoramas, the designers intended that it be difficult to tell where the painting ended and the spectator's space began. A canopy over the heads of the audience blocked the top edge of the painting from sight, while the bottom edge appeared to merge seamlessly with objects placed before the picture. If the image showed a beach, for example, a bed of real sand might be placed in the space between audience and painting.

Nonetheless, how any of this relates to seeing "at a glance" needs explanation. It makes little sense to suggest that a 360-degree, wrap-around view bears any relation at all to what we see when we glance at the world. By virtue of the fact that it extends behind the spectator, it is difficult to wed the panoramic painting to the appearance of objects under any conditions of viewing, from a glance to a blink to a gaze, and imagine the painting gives its viewers access to that appearance. The panorama painting shows too much world, surpassing any individual case of seeing. Perhaps because its contemporaries were uncomfortable with a painting that had such a tortured relation to what we see, one does find attempts to link the panoramic painting to certain viewing conditions, to suggest, for instance, that the panoramic painting shows what you see when you stand in one spot and spin around.[29] Even though this assertion is utterly untrue to the visual reality of the representational form, we cannot simply abandon what certain of the panorama's contemporaries imagined of it. In regard to the question of the glance, however, it seems far better to suggest that, rather than showing how the world looks when a person glances at it, a panoramic painting makes glancing activity possible—even necessary—on the part of the audience.

Owing to its sheer size, the panoramic painting offers viewers more than they can possibly assimilate, and always contains aspects that remain at the periphery of their attention and awareness. This is not to deny that, when we look at paintings of more normal dimensions, the act of doing so unfolds in a sequenced fashion, with particular spots receiving attention at particular moments. Yet, there is a qualitative dissimilarity between the kind of scanning that goes on when we try to grasp the fullness of a normal painting and when we try to grasp the fullness of a panorama.[30] The panoramic painting does not claim to be constructed around a main focus, but instead to hold the infinity of all possible foci that would be available to an observer at the scene. At any moment, any number of these possible centers must be neglected. In this sense, looking at a panoramic painting would be like looking at an actual scene or at a photograph of that scene in Holmes's description. The panorama is a synthetic or total form of representation, because it holds this wealth of centers within itself. We could, of course, look at a panorama for a long period of time in an effort to get to know all these centers, but even then we would only come to know the work as we might a well-studied view in the real world, or a well-studied photograph, both of which Holmes maintains are theoretically "inexhaustible."[31]

In this vein, one might consider some of the spectatorial habits that accompanied the "Great Paintings," by Frederic Edwin Church, Thomas Cole, and others, which were so popular in the United States during the nineteenth century. The "greatness" of these paintings was principally a matter of their large size, a fact that has caused observers both then and now to link them with panoramas. Further, as other scholars have noted, the conditions of seeing works such as Church's *Niagara* or *Heart of the Andes* closely matched those of seeing panoramas.[32] Viewers would pay admission, enter a dimly illuminated room, and sit on benches to stare at an enormous, brightly lit canvas. With the intention of creating the impression that one looked out at a scene in the material world, the exhibitors sought to establish the illusion that light was emanating from the painting itself, doing so via cleverly managed gaslights and skylights. In the case of *Heart of the Andes*, Church fashioned a frame to suggest that one beheld the scene through a window.[33] Most strikingly of all, viewers were asked to participate in the kind of looking that Holmes considered appropriate to photographs—they were encouraged to use opera glasses and binoculars to inspect the canvas, acting as though they were actually before the pictured spot.[34]

Because Church's paintings possessed an accepted kinship with panoramas, they were open to the charge they did not do enough to elaborate an artistic vision of the object, a vision that incorporated human consciousness into itself by its selection of points of attention. One hostile critic noted of Church's work: "A picture is a picture, and not an actual scene, and all attempts to make it any thing more than a picture belong to the cosmoramic and dioramic order of art."[35] One might also consider the following discussion that appeared in 1870 in Holmes's favored venue, the *Atlantic Monthly*, in which a man of culture addresses a "man of dollars":

> You must be a patron of art, too; that is, you are one of those men of dollars who are engaged in corrupting all the promising painters of the land by urging them to the production of panoramic pictures, in which there shall be an almost photographic representation of some strange or big thing in nature, but in which all the life and spirit of nature shall be left out. You value things in art just in proportion as they recede from the artistic. Here is a little picture, representing a bit of grass, a cow, and a cottage. How you turn up your nose! There's nothing in it to create a sensation, I admit; but there is something in it to touch a sentiment, if sentiment you had to touch. The landscape is thoroughly humanized, sir, and if you had ever seen a simple landscape in nature,—you've stared, no doubt, at thousands,—you would feel the fact.[36]

The "humanized" vision at issue centers on the distinction between "seeing" and "staring." Seeing, with its emphasis on the humanization of the world via selection and attention, correlates to painting, while staring, with its suggestions of a mindless and aimlessly open reception, coincides with photographic and panoramic representation. The passage is also significant for its suggestion, a rather ugly one, that "staring" may actually correspond to the perception of certain human types, ones so debased, mindless, and material that proper "seeing" is beyond them.[37] The essential point in the foregoing, however, consists in the idea that, owing to their status as total representations, panoramas and photographs diverge from what human observers see in perception.

THE PANORAMIC PROJECT OF JOHN WESLEY JONES

Having considered the relationship of photographic and panoramic representation to perception, we must bear in mind that this account refers to only one of the many understandings that nineteenth-century observers brought to this question. Another approach presents itself in the epic project of John Wesley Jones.[38] George Wheeler declared in his prospectus for 1873, when O'Sullivan accompanied him as the expedition's photographer, "the time has come to change the system of examination, from that idea of exploration which seems to attach itself to a linear search for great and special wonders, to a thorough survey that shall build up from time to time, and fortify our knowledge of the structural relation of the whole."[39] Although what exactly Wheeler meant by this statement is complicated, he was clearly responding, as we will see, to depictions of the West similar to those Jones provided and earlier explorations such as John Charles Frémont's.[40]

Jones's expedition of 1851, conceived in order to daguerrotype the emigration route between California and the East, is particularly noteworthy in the present context, not only for its sheer audacity, but also for the way in which it brought together photographs and panoramas. The serious technical problems Jones faced in using the cumbersome daguerreotype technology under these conditions, as well as the very real physical perils he encountered, makes it difficult to believe that he actually undertook the journey, but modern scholarship has established that he did so.[41] Jones did not think of the daguerreotypes as an end unto themselves but as a draft material on which he would base an enormous moving panorama called a "Pantoscope."[42]

Moving panoramas, in the mid-nineteenth-century United States, had become a popular attraction, above all in the depiction of the West. These exceedingly long paintings were mounted on a pair of rollers; when the rollers turned, the painting would slowly pass before the spectators, offering them, at any given moment, a small and limited view of a certain portion of its length.[43] Often displayed on an auditorium's stage, the painting would present the sight of a continuous landscape, one meant to simulate what the audience would see if traveling on a stagecoach or sailing down a river.

Jones had artists paint his Pantoscope, which was on exhibition in Boston and New York during 1853–1854, from what were allegedly more than 1,500 daguerreotypes. During shows, Jones himself would deliver a lecture and oral presentation regarding what the audience saw unroll before them.[44] There are significant differences between moving panoramas such as Jones's Pantoscope and cycloramas. In the first place, Jones's work embodies that idea of "a linear search for great and special wonders" against which Wheeler complained. It seeks to depict a single journey or route that links West and East, displaying, in sequential order, the especially noteworthy sites one would come across on the trip: Steeple Rocks, Chimney Rock, the "grandly wild and picturesque" Scott's Bluffs, and so forth.[45] Second, in putting these sites within the order one would see them on the trip, Jones has no interest in Wheeler's "thorough survey that shall build up from time to time," but seeks only to represent one particular temporal segment, what one sees on a journey from point A to point B. Put another way, Jones tries to provide his audience with a series of

pictures that accord with a particular viewing experience, that match how things looked to an observer in Jones's company on the expedition. The painting never attempts to surpass human perception.

The full sense of this matter becomes apparent by returning to an issue Holmes raised, the depiction of motion by photography. In Holmes's account, photography's significance as a means of registering motion proceeded from discrepancies between the photographic picture of motion and what we see when we look at a man walking. Holmes has comparatively little interest in using photography to make pictures of events that would be redundant with what we see, and with what painters have traditionally represented; rather, he looks to photographic practices that shows us unexpected and otherwise imperceptible dimensions of events. Jones has a different conception of photography's overall purpose. In his promotional booklet *Amusing and Thrilling Adventures*, Jones included a section given over to encomia of the press, awestruck pronouncements from journalists regarding the marvel he had created. One passage from the *Congregationalist and Christian Times* addresses Jones's representation of human motion:[46]

> All the varieties of mining life pass before us, and all the processes of mining. Nay, we see the very identical miners who were at work when the views were taken, in the very attitudes of real work; for they kept their positions for a time, by request, that the daguerreotypes might fix them *forever*. . . . On looking at these scenes, one feels a confident assurance that they accord with the realities.[46]

Whereas Holmes would argue that photographs of motion were important precisely because an audience did *not* feel a "confident. . . assurance that they accord with realities," for Jones, photography only has application insofar as it renders pictures that meet our expectations and conform to our visual experience.

We see this fact in Jones's comfort with selecting a particular pose by which to represent motion. In the above case, the specific motion in question, say, swinging a pickaxe at a rockface, may have been something that the easterner Jones, as well as his audience, had no prior experience of seeing. If that was so, I imagine he simply observed the miners for a certain period, as an artist would, until he had formed an idea of what their motion looked like. He then would have asked the miners to assume the pose most typical of a man swinging a pickaxe. Although it is impossible to know which pose Jones would have selected, many contemporary discussions suggested those phases of rapid motion that lasted longer than the others and so were seen for a longer period were the ones that characterized the motion to perception.[47] Jones told the pickaxe-man to hold the chosen pose and produced a daguerreotype of it for subsequent inclusion in the panorama. This procedure for the representation of motion, by the way, is the same as that which commentators such as H. J. Stack claim took place in painting.[48] Jones has no interest in, and possibly no conception of, what it would mean to use photography to go beyond what perception discloses. He seeks representations that accord with our expectations of what the motions should look like, even when the motions are themselves unfamiliar.

Indeed, when we consider the "confident assurance" that the audience should experience when looking at the

pictures, we see the remove at which Jones's conception of photography operates not only from that of Holmes, but from that of most people today. Jones also includes an excerpt from the *Boston Traveller*: "The scenes presented have a life likeness that abundantly attests their indentity [*sic*], even to those who have not seen the land of gold, while those who *have seen* it, give it their unqualified approval."[49] This is a noteworthy assertion, one whose full importance we must consider. Let's suppose a photographic project today gives us images of a subject that many people have never seen, say, the lunar landscape. The people who produced these photographs of the moon would probably not claim validity for them by saying that "even those who have never visited the moon and have only limited astronomical knowledge find that these images accord with the realities." Although we should not discount the second part of the above statement ("those who *have seen* it, give it their unqualified approval"), its association with the first claim suggests a particular conception of truth-telling, one that many readers today would find it odd to see linked with photography. Photography's importance, within Jones's work, derives from its ability to contribute to a project that renders familiar. For Jones, telling the truth about some new object, like the unexplored territories of the West and the strange activities that go on there, means to make it familiar, to demonstrate that the principles that order human experience in the domains we already know have application in the new one as well. For this reason, matching the expectations of audiences, in regard to how they think either a motion or a new land should look, is of central importance to him.

Panoramas in the Western Surveys

The photographic projects of Bell and O'Sullivan, within the context of the King and Wheeler expeditions, answer to different imperatives when we consider the questions of the familiar and the expected. Making broad assertions about these photographs, panoramic or otherwise, is a delicate business, as it remains unclear what purpose the images of Bell and O'Sullivan served on the expeditions. Although many scholars have insisted that the photographs were meant to be useful as scientific documents, we know King saw them as only fit for the more modest goal of providing "generally descriptive" images that could "give a sense of the area."[50] It is also very clear, just looking at the photographs, that the extraction of any kind of useable, quantifiable, scientific data from them would actually be rather difficult (figure 26). In regard to the panoramas, understanding their purpose is even more challenging because, so far as anyone knows, they were on exhibit just once, at the Philadelphia Centennial Exposition of 1876—two panoramas by Bell and one by O'Sullivan.

While we may never know with certainty why photography was used on these expeditions, we can establish certain of the representational strategies that governed how it was used. Ever since some of the earliest historians of photography rediscovered the work of Bell and O'Sullivan in the 1930s, commentators have emphasized how strange, discordant, and alien the western territories appear in these images. Thinking specifically of O'Sullivan's work, Ansel Adams opined that it was "technically deficient, even by the standards of the time, but nonetheless, surrealistic and disturbing."[51] The repertoire of techniques by which these

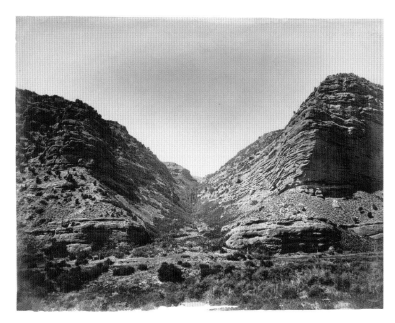

FIGURE 26

Timothy O'Sullivan, *Echo Canyon, Utah*, 1868
Cat. 9

FIGURE 27

Timothy O'Sullivan, *Hot Springs Cone, Provo Valley, Utah*, 1869
Photograph: National Archives and Records Administration

"surrealistic and disturbing" pictures come to be, in which the West appears as anything other than a welcoming land, a handy and masterable place meant for humans, is large. In some of his most famous images, O'Sullivan creates bizarre juxtapositions for his viewers. Seeking to demonstrate that a tufa cone is hollow, he had an assistant climb into it, so that a human head seems to grow from a hot spring's cone (figure 27). On other occasions, the images appear to be almost programmatic statements regarding the triviality of the human figures placed in them and the terms by which they try to make sense of the immense western landscape (figure 28). These small figures do not serve as a way to mediate between the viewer and the land, to humanize the wilderness for viewers, but instead underscore the utter indifference of the landscape to our presence and the irrelevance of the categories by which we know and perceive it. The world presented here is the face of the sublime, too vast for our comprehension. At the same time, as in Bell's 1872 *Looking South into the Grand Canyon, Colorado River, Sheavwitz Crossing*, it frequently becomes impossible to establish where we could possibly be standing to attain the view the photograph offers (figure 29). The images

problematize the ways in which we normally experience space, and abolish the conditions by which it becomes coherent for us. Some historians have argued that the West looks so alien and inhuman in these works that we must treat the images as figurative "no trespassing" signs, proclamations that only scientists and experts may venture into this land.[52]

Such a deployment of photography, with its basic indifference to the nature of human perception and the way in which it makes sense of the world, accords with those views of the medium that emphasized the rift between it and what we see. Because, to someone of Clarence King's understanding, the terra incognita of the West represented an unfamiliar, overwhelming, and incomprehensible world, photography would have promised special resources for its depiction. In King's view, western geology bore, more manifestly and awfully than the lands of the East, the mark of the hand of God, in that the western landscape had taken its form via divinely ordained catastrophes. Confronted with such a land, frightening in appearance and immense beyond measure, the terms of human experience appear puny and irrelevant.[53] Precisely because photography was not bound to the ways in which humans experience the world, it could have a place in depicting a world of such a kind. From this perspective, the panoramic work of Bell and O'Sullivan appears as a radicalization of the basic drives within their western photography, as a form of representation with an even more attenuated link to our familiar perception. Panoramic representation, like the boundless and sublime territories that Bell and O'Sullivan sought to represent, surpasses human seeing.

Although this position to some extent grows out of the foregoing discussion of panoramas, there are also ways in which these photographs diverge from seeing that go beyond cycloramas. While cycloramas did nothing to represent the world-as-seen, they did attempt to make it possible for viewers to believe that they were seeing the world from a particular vantage, say, London Bridge. The photographic panoramas from the geological surveys, such as the ones by Bell composed of five or more separate prints (figures 18–20), would have had great difficulty contributing to such an

After William Bell, *Looking South into the Grand Canyon,*
Colorado River, Sheavwitz Crossing, 1872
Cat. 73

end. This was partly because of the conditions of display for which they were probably intended. Such images were almost never mounted on a circular support in the middle of which a viewer could stand, but were nearly always presented against a flat wall, as though a cyclorama had been unrolled. This image could indeed document a place but, by the rules according to which we see, spatial understanding of the landscape, the angular locations of objects in the field of view, and mutual distances between these objects all become difficult to grasp.[54]

Although it should be clear how the photography of Bell and O'Sullivan departs from projects such as Jones's, there is some shared sense of what photographs should accomplish. In the end, perhaps because their endeavors belong to a historical moment of transition, Bell and O'Sullivan possess a hybrid identity, and never fully dispense with some of Jones's concerns. Owing to the place it has occupied in this discussion, there seems no better way to conclude than by returning to the representation of motion. In 1867–1868, while on expedition with King, O'Sullivan tried his own hand at photographing miners. Fitting out a special kit, he descended into the Comstock Lode in Nevada, producing the first photographs ever taken in the confines of a mine. Aside from the difficulties inherent in getting the photographic apparatus into the mine and using it under such conditions, O'Sullivan also had to contend with the darkness of this subterranean world, and so took the innovative step of using magnesium flares. By this means, he could get sufficient illumination to make his unprecedented images of miners at work below the earth. These photographs match up well with certain understandings we have today of photographic

FIGURE 30

Timothy O'Sullivan, *Mouth of Curtis Shaft. Savage Mine, Comstock Lode Mine Works, Virginia City, Nevada*, ca. 1867
Photograph: National Archives and Records Administration

FIGURE 31

Timothy O'Sullivan, *At Work—Gould & Curry Mine, Comstock Lode Mine Works, Virginia City, Nevada*, 1868
Photograph: George Eastman House

truthfulness, showing a viewer the frightening and unknown life of western miners (figure 30). Yet, there are other images from the descent into mines that seem to belong to an earlier conception of photography. After O'Sullivan went to the trouble to get his apparatus into the mines, it is clear he still asked the miners to pose in at least certain of the prints, above all those that showed movement. In those images, he picked a moment of rest in the motion, the moment that was supposed to characterize an act in the eye's perception of it and so match a viewer's expectations (figure 31). Although questions of exposure time must have played a role here, the fact O'Sullivan had recourse to such an expedient shows that images of the strange and alien did not hold total sway in his work on the western expeditions. Other forms of photographic practice, ones that sought to jibe with the eye's experience, also had a place.

NOTES

1. Panoramic painting made its first appearance in 1787, courtesy of the Edinburgh artist Robert Barker. Within a short period of time, it had become something of a craze; imitators of Barker's technique proliferated throughout Europe and the Americas, and many different subtypes of panorama (the diorama, the moving panorama, etc.) came into being. The two most comprehensive accounts of panoramic painting in the literature are Ralph Hyde, *Panoramania!* (London: Trefoil Publications, 1989) and Stephan Oettermann, *The Panorama* (New York: Zone, 1997). Because Barker's were the first images actually to be called "panoramas," and because their novelty was seen to make them worthy of a patent, I follow the scholarly literature and take his paintings to be the first instances of the panoramic genre.

2. As a general rule, when directly in touch with panoramic representation, photography was used to make preparatory images that artists would subsequently copy in the making of a drawn, painted, or engraved panorama. Yet, even in 1843, the same year that saw the first use of daguerreotypy in the preparatory work for a panorama, we find an effort to make a panoramic image out of photographs themselves; see Hyde, *Panoramania*, 179–80. Because most of the present discussion is given over to fleshing out relations between photographs and panoramas, I only flag this matter here.

3. H. J. Stack, "Photography as a Fine Art," *Intellectual Observer* 10 (1867): 20.

4. Sir William J. Newton, Lady Elizabeth Eastlake, and Charles Baudelaire all, in different ways, argued for the discrepancy between photography and vision. Their essays are all reprinted in Beaumont Newhall, ed., *Photography: Essays and Images* (New York: Museum of Modern Art, 1981).

5. Father of the celebrated jurist, Holmes (1809–1894) was a famous physician, essayist, and humorist who, during the late 1850s and early 1860s, published in the *Atlantic Monthly* a series of immensely stimulating articles concerning the nature and use of photography. These writings are all gathered together in Holmes's *Soundings from the Atlantic* (Boston: Ticknor and Fields, 1864). Any citations of Holmes in the present essay come from this volume.

6. Holmes, "The Stereoscope and the Stereograph," 161, italics in original.

7. Ibid., 125.

8. Ibid., 124.

9. Of Holmes's claim that we perceive in pictures, see how he distinguishes between vision and photography: "Our own eyes lose the images pictured on them"; "Sun-Painting and Sun-Sculpture," 170.

10. Ibid., 167.

11. Ibid., 169–70. Holmes is rather fond of this formulation, repeating it in his "Doings of the Sunbeam" essay from 1863: "But again another view shows us a wholly different aspect, which is yet as absolutely characteristic as the first; and a third and a fourth convince us that our friend was not one, but many, in outward appearance." Holmes, "Doings of the Sunbeam," 260.

12. I refer here to the studies of human and animal locomotion undertaken in the 1870s by the American Eadweard Muybridge, on which the Frenchman Étienne-Jules Marey followed up, far more rigorously, in the 1880s. Both enterprises sought to capture phases of motion that happen too quickly to be seen.

13. Holmes, "The Human Wheel, Its Spokes and Felloes," 294.

14. There is almost certainly some physiological limitation at play. That is, even if we say the choice of one or two postures made the others vanish, Holmes would seem to believe that people reliably select the same one or two postures to use as stand-ins for the motion. It is for this reason that artists can safely use certain postures in depicting motion.

15. Although their positions are not interchangeable, Holmes's arguments here bear a certain similarity to the famous claims André Bazin made about photography a hundred years later. See Bazin's "The Ontology of the Photographic Image," in *What Is Cinema?*, vol. I (Berkeley: University of California, 2005), 9–17.

16. Holmes, "The Stereoscope," 148–49.

17. "The beauty of your photograph is, that you may work out minute details with the microscope, just as you can with the telescope in a distant landscape in Nature"; Holmes, "Sun-Painting," 193–94. Holmes was very fond of taking magnification devices to photographs, and one finds many examples of the delight he takes in doing so throughout his writings.

18. Joel Snyder, *American Frontiers* (New York: Aperture, 1981).

19. Holmes, "Sun-Painting," 180. I confess to taking this quote slightly out of context. Holmes makes this comment about a photograph of

the Old Man of the Mountain, a New Hampshire rock formation that many observers claimed bore a striking resemblance to a human profile. He marvels at how it looks like a human face in the photograph, without having received any help from a painter. Because the quote can also speak to the most important dimensions of Holmes's argument, however, I press it into this duty.

20. Ibid., 178.

21. Ibid., 201. For further examples of Holmes's treatment of photographs as a form of ersatz travel, see "Doings of the Sunbeam."

22. "Panoramic Excursions," *Weekly Reveille*, April 22, 1850, cited in Martha Sandweiss, *Print the Legend* (New Haven: Yale University Press, 2002), 53. The article goes on to celebrate how, thanks to the panorama, we can "revel in all the riches and beauties of nature" without the irritations of having to travel.

23. *Peoria Democratic Press*, October 2, 1850.

24. "Mr. Vance's California Views," *Photographic Art Journal* (October 1851): 252–53.

25. See Oettermann, *The Panorama*, 6.

26. Oettermann's book, as a narrative of the development of panorama-types, is as good an account as one will find in the literature. I leave aside, in the present examination of relations between photographs and panoramas, Daguerre's own involvement with panoramas: his invention in the 1820s of the diorama.

27. See *The Compact Oxford English Dictionary* (Oxford: Oxford University Press, 1991), 1265.

28. For a work of the first type, consider Robert Barker's 1792 panorama of London, painted from the roof of the Albion Steam Flour Mills near Blackfriars Bridge. For a panorama of the second type, see his 1795 "Lord Howe's Victory and the Glorious First of June"; see Oettermann, *The Panorama*, 101–106.

29. *The Encyclopedia Britannica* in 1801, for example, discussed the panorama in such a way as to attempt to link it to this experience: "*Panorama*, a word . . . employed of late to denote a painting . . . which represents an entire view of any country, city, or other natural objects, as they appear to a person standing in any situation, and turning around." Other ways in which the word was used at the time, because they divorce it from a viewing experience, are more useful. *The Compact Oxford English Dictionary*, which also

supplies the previous citation, encapsulates these other uses by a definition of panorama as "A complete and comprehensive survey or presentation of a subject," 1265.

30. Michael Fried's writings have some application here. Of what it means to look at a successful work of modern art, he writes: "It is this continuous and entire *presentness*, amounting, as it were, to the perpetual creation of itself, that one experiences as a kind of *instantaneousness*, as though if only one were infinitely more acute, a single infinitely brief instant would be long enough to see everything, to experience the work in all its fullness, to be forever convinced by it"; "Art and Objecthood," in *Art and Objecthood: Essays and Reviews* (Chicago: University of Chicago Press, 1998), 167, italics in original. This is a promise without substance in the case of the panorama. There is never a sense that a panorama asks to be seen as something that could be grasped in one instant, any more than a natural object asks for such treatment.

31. Holmes, "The Stereoscope," 148.

32. I borrow these details of the experience of looking at "Great Pictures" from Iris Cahn's "Early Film and America's 'Great Picture' Tradition," *Wide Angle* 18 (July 1996): 85–100.

33. See Kevin J. Avery, "*The Heart of the Andes* Exhibited: Frederic E. Church's Window on the Equatorial World," *American Art Journal* 18 (1986): 57.

34. Cahn ("Early Film," 89) points out this use of opera glasses, as does Barbara Novak, *Nature and Culture* (New York: Oxford University Press, 1980), 26, and Gerald L. Carr, *In Search of the Promised Land: Paintings by Frederic Edwin Church* (New York: Berry-Hill Galleries, 2000), 15.

35. *New York Post*, April 30, 1859, 2.

36. "Mr. Hardhack on the Sensational in Literature and Life," *Atlantic Monthly* 26 (August 1870), 197, as cited in Emily Godbey, "Rubbernecking and the Business of Disaster: Painting, Photography, Cinema, and the Culture of Catastrophe" (Ph.D. diss., University of Chicago, 2005), 115.

37. Although they do not argue for correlation between the camera and the "man of dollars," both Baudelaire and Eastlake also suggest that, while the camera departs forcefully from sound seeing, certain strains of humanity are so low that there is far less diver-

gence between their perception and photography. Such classes of person are soulless and dumb automata. The question of how photography relates to the perception of *certain* humans is a chapter in the social history of photography that remains to be written.

38. Because his daguerreotypes have not yet been found, and possibly no longer exist, Jones's project has received little scrutiny in the literature on history of photography. For the main discussion of Jones, see Sandweiss, *Print the Legend*, ch. 2. The only other mention of Jones that I have been able to find is in Oettermann, *The Panorama*, 325.

39. As cited in William Goetzmann, *Exploration and Empire: The Explorer and Scientist in the Winning of the American West* (New York: Knopf, 1966), 478.

40. In addition to his work *Exploration and Empire*, Goetzmann's *Army Exploration in the American West, 1803–63* (New Haven: Yale University Press, 1965) provides a valuable discussion of Frémont.

41. Sandweiss has established the reality of Jones's endeavor. Of the perils he encountered, the harshness and wildness of the land must be counted as the overriding ones, although Jones's party also seems to have come under attack more than once. In a story that made its way into *Harper's Monthly*, Jones allegedly scared off a band of Native Americans by pretending that his camera was a gun. While these attacks may be fanciful, they also may not be—we know that in 1871, just hours after parting company with Wheeler's expedition, Frederick Loring, the son of a prominent Boston family, was killed by Apaches.

42. Jones describes the Pantoscope, his journeys out West, and his use of daguerreotypy in the booklet he, along with John Ross Dix, produced in connection with the Pantoscope's exhibition in Boston and New York City during 1853–1854. See *Amusing and Thrilling Adventures of a California Artist while Daguerreotyping a Continent* (Boston: Published for the Author, 1854).

43. Because panorama-impresarios were not always scrupulous, it would be foolish to accept some of their wilder pronouncements on the length of their canvases: "Over 4 miles!," etc. Nonetheless, because sessions in which moving panoramas were unrolled for audiences could last over an hour, their total lengths, in some cases, must have been prodigious. For a fuller discussion, see Sandweiss, *Print the Legend*, 64; and Oettermann, *The Panorama*, 323–30.

44. This number of daguerreotypes is not credible. Although Jones did go on this remarkable expedition to the West, that does not mean he was immune to making the inflated claims of a showman trying to drum up business. His lecture notes do survive; see Sandweiss, *Print the Legend*, 72.

45. Jones, *Amusing and Thrilling Adventures*, 57.

46. Ibid., 46, italics in original.

47. The English scientific investigator Francis Galton made this point a few years later: "Thus, in making a drawing of a pendulum in the act of swinging, we should always represent it at one or other side of its excursion, when it delays for an instant, and returns. We see it longer in either of those extreme positions than in any of the intermediate ones. Similarly, we draw a man walking, or otherwise in motion, in the attitude where there is a momentary change of direction, and consequently more or less of rest at or about that position"; "Generic Images," *Nineteenth Century* 6 (July 1879): 165.

48. Stack maintains, "Natural objects are more or less in motion, and more or less affected by motions of light and shade upon them, and the artist has to select and stereotype one out of many successive appearances presented to his view"; "Photography as a Fine Art," 20.

49. Jones, *Amusing and Thrilling Adventures*, 45, italics in original.

50. Cited in Joel Snyder, "Territorial Photography," in *Landscape and Power*, ed. W. J. T. Mitchell (Chicago: University of Chicago Press, 1994), 192.

51. Letter from Ansel Adams to Beaumont Newhall, cited in ibid., 192.

52. Snyder makes this claim in ibid., 200.

53. William Goetzmann's classic account *Exploration and Empire* (op. cit.) contains a particularly valuable discussion of Clarence King's view of the western landscape and the sublime. See ch. 12, "The West of Clarence King."

54. For further discussion of these aspects of photographic panoramas, see Dariusz Czarniawski et al., "Immersive Photographic Panoramas of Cultural Heritage 1873–2002 in Dynamic Viewers On-line (Internet & CD Media Project)," abstract of paper at UNESCO Virtual Congress, October–November 2002, http://www.eurofresh.se/history/.

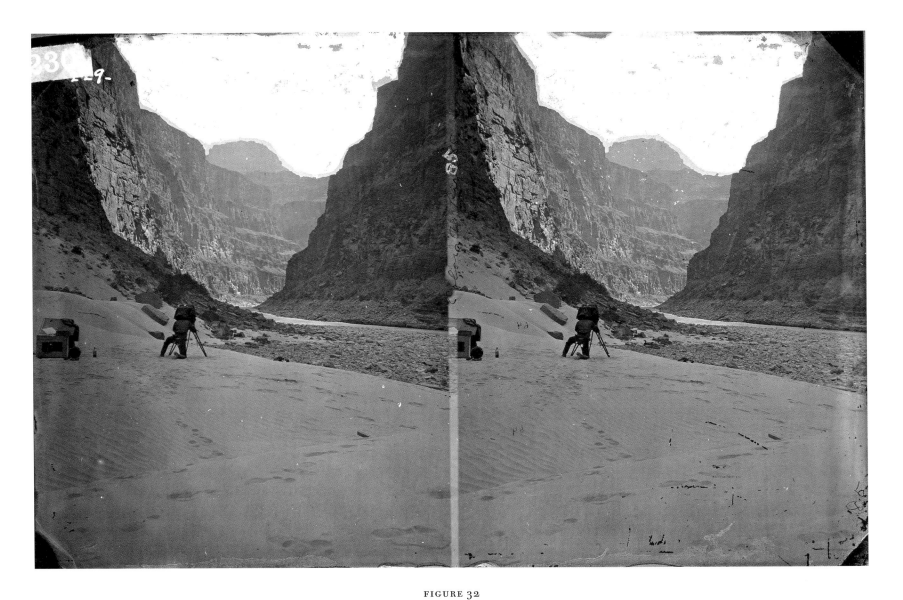

FIGURE 32

William Bell, *Grand Canyon, Mouth of Kanab Wash or Creek, Colorado River*, 1872
Albumen print from stereographic negative
Photograph: National Archives and Records Administration

JOEL SNYDER

Material Practices: Negatives in Collodion, Positives in Albumen

THE DAGUERREOTYPE PROCESS, made public in 1839, was the first commercially successful method for making camera-generated pictures. The technique produced one-of-a-kind images on highly polished plates of silvered copper. Within five years of its announcement, daguerreotype portrait studios were operating in all the major cities of Europe and North America, and the process remained the dominant one until well into the 1850s. For all their virtues—sharpness and relative ease of production being the most prominent—daguerreotypes were little more than personal keepsakes, since they could not be published in books (though they could be copied by hand as steel or wood engravings or as lithographs) or sold in multiple editions.

The wet plate collodion process replaced the daguerreotype between the later 1850s and the early 1880s, transforming photography into a paper print medium. All of the prints by Timothy O'Sullivan in this exhibition were made from wet plate collodion negatives, while those by William

Bell were prepared from negatives made with a variant method—the difficult, and thus rarely used, dry plate collodion process.

The invention of the wet collodion system for making negatives was published by Frederick Scott Archer, an English photographer, in 1851. Its photochemical character derives from the older paper negative process patented by the Englishman William Henry Fox Talbot in 1841 (under the name "The Calotype Process of Photogenic Drawing") and from improvements to that process published in 1848 by the French cotton merchant Louis-Désiré Blanquart-Évrard. Like other photographers of the time, Archer was searching for a predictable method of making negatives on glass or some other transparent base. Most photographers thought that paper negatives suffered from three great disadvantages: they tended to print in broad, generalized masses (some observers thought this to be "naturalistic" or picturesque); the texture of the paper interfered with the printing of fine detail contained in the negative; and it took many minutes and sometimes many hours to print them, a factor that made it impossible to produce large runs at prices that were competitive with older graphic processes.

Archer turned to collodion, a recently invented liquid that was clear and colorless and dried to a tough and completely transparent, cellophane-like film. Collodion is made by dissolving gun-cotton, a variety of highly flammable and potentially explosive nitro-cellulose, in ethyl ether (the ether used in surgery) and ethyl alcohol (the alcohol found in alcoholic beverages). By itself, collodion has no photographic properties, but Archer found that he could dissolve simple, non-photographically sensitive salts in collodion—iodides, chlorides, and bromides—pour the mixture (called "iodized collodion") over a clean glass plate, and then make it sensitive to light by dipping it in a bath of silver nitrate crystals dissolved in water. Sensitizing the plate had to be done in a light-tight space illuminated solely by red or orange light. It took between two and three minutes for the silver nitrate to react with the salts in the collodion to form light-sensitive silver iodide, chloride, and bromide.

The plate retained its photographic sensitivity only while wet. In practice, this required the photographer to set up the camera, focus it, and then return to the darkroom to pour the collodion on a sheet of glass and sensitize it. Once this was done, the plate was placed into a light-tight holder, transported quickly to the camera and inserted into its back. Exposure routinely ran anywhere from five to thirty seconds. The plate was then quickly returned to the darkroom where it had to be developed while still wet. It was then rinsed in water, fixed in a solution of either standard photographic fixer or potassium cyanide, washed, and dried. Often development failed to produce a negative that was strong enough to print well, and in such cases the photographer invigorated the negative (that is, gave it more contrast) by treating it in a bath of chemical intensifier. Once the processing was completed and the plate washed in water, the photographer protected the fragile collodion film by coating it with varnish and allowing it to dry.

This is a bare-bones account of the wet plate process, and, accordingly, it excludes a mass of practical details—the various recipes for iodized collodion that work to flatten or increase contrast, the knacks of hand that kept the collodion from streaking or forming striations while being

poured, the matters of judgment about exposure that were gained through bitter experience—the crucial elements that gave life to the process. It also assumes that each part of the process always behaved at its best, but each could be recalcitrant, resistant, perverse. Newly iodized collodion had to be aged—it often gave unacceptable negatives if it was used too soon after mixing, while old iodized collodion might produce "rotten" films that did not adhere well to the glass or that refused to sensitize. Perhaps most confounding to photographers was the possibility that the silver bath in which the plates were sensitized might suddenly and without warning give negatives that were peppered with a mass of spots or with blank areas called "apertures" and "comets." And the possibility of each of these dreaded problems was greatly increased once the photographer moved out of the space of the studio and took to the field.

To photograph in the field using the wet plate process, O'Sullivan had to bring two large, bulky, and heavy cameras and some contrivance that would function as a darkroom. He was lucky to have a converted army ambulance as a moveable darkroom, but he also used a small tent that he could set up in a boat or on land in places that could not be reached by wagon. In addition to bringing a darkroom along wherever he photographed, he had to transport bottles of chemicals, many sheets of glass, trays, and, at times, his own supply of water. Beyond the usual challenges of the wet plate process, O'Sullivan discovered new problems—much-needed water was in scarce supply in desert regions, and the water that was available in some areas was often highly alkaline and worked to neutralize the developer, which had to be used in an acidic condition. Moreover, even an operation

like coating a finished negative with varnish, which was a relatively easy matter in a studio darkroom, became a nightmare when O'Sullivan processed his plates in windswept, dusty New Mexican fields, and airborne insects and dust particles settled on the tacky surfaces of his just-varnished negatives. The process demanded that O'Sullivan work in a constant state of near-frenzy. He would first locate a place that seemed to have promising pictorial possibilities. Then he would unpack his cameras and, if he was working away from his wagon, set up his tent. Once he had composed the view on the ground glass of one of the cameras, he would walk back to his darkened working space, pour a plate, sensitize it, place it in a plate holder, and, in order to keep the plate in its wet condition, race to the camera. The plate would then have to be exposed as soon as possible for upward of thirty or forty seconds and then run back to the darkroom, where it would be immediately developed and processed. This procedure had to be repeated for every plate he exposed.

In his progress report for the field year of 1872, George Wheeler included a special mention of William Bell, who had taken O'Sullivan's place for that season. Wheeler wrote: "I would here mention that Mr. Bell has successfully used the dry-plate process with negatives prepared by himself, and is worthy of commendation for his interest and industry in his attempt to perfect this process."[1]

The dry plate process freed Bell from bondage to a wagon or tent by allowing him to prepare sensitized plates at a base camp one or two days in advance of exposing them, and likewise permitted him to postpone development and processing for upward of a day after exposure. Dry plates

made photography in the field, especially under trying conditions of exploration, far more convenient than wet plates. Their drawbacks, however, were considerable. Preparing the plates was even more time consuming, and the results were often unpredictable. Dust that settled unnoticed on the sensitized surface of the plates while they dried could produce vigorous, unsightly swirls in the finished negatives, rendering them useless. Nonetheless, Bell mastered the process, and his two stunning landscape panoramas reproduced in this book (see figures 18–20) were almost certainly made with dry plates. Bell was among a handful of photographers working at that time who possessed the technical skill and self-confidence to use dry plates under constantly changing and stressful conditions.

PRINTS FROM NEGATIVES

The printing of the survey negatives was done in Washington in more comfortable circumstances than those found in the field. Before being printed, many of the negatives had to undergo special preparation called "doctoring." The collodion processes, like all other photographic processes then available, was sensitive only to the blue and ultraviolet components of visible radiation. In the mountains of the West, the sky is typically rich in these rays. This meant that when photographing a landscape, the sky portions would expose far more quickly than the ground areas and were likely to receive massive overexposure. When developed, areas that should have appeared as light gray would often show as mottled swirls of blacks and gray. In order to remedy this problem, landscape photographers were forced to trace along the horizon line with an opaque fluid that would separate the horizon from the mottled sky (see figure 32). Once this was done, the remainder of the patchy sky area was covered with thick manila paper, so that the entire sky portion of the plate would block all light that fell upon it. Many of the negatives produced by O'Sullivan and Bell required doctoring of this kind before they were printed.

The negatives were printed by contact on albumen paper, which had become the most common photographic support by the early 1860s and could be purchased at any photographic supply house. It is made by floating sheets of tough but lightweight paper that could withstand long soaking on a bath of slightly salted egg whites that had been whipped into a meringue and allowed to settle overnight. After being floated on the egg whites, the sheets were hung to dry. When needed for printing, a sheet of albumen paper was floated for two or three minutes on an aqueous solution of silver nitrate and then hung to dry in a darkened area. The negative was placed in a frame, film side facing inward, and pressed against the silvered albumen paper in direct and uniform contact by means of a spring-loaded back. This sandwich of negative, paper, and frame back was then placed in the sunlight for as long as it took to somewhat overprint the positive image. The process required no development. The exposure could require two or three minutes, but might take significantly longer depending on the density and contrast of the negative. High-contrast negatives were printed in direct sunlight, which tended to lower the contrast of the print, while low-contrast, "muddy" negatives were printed slowly in the shade in order to increase contrast. Exposures were checked by lifting a small portion of the albumen paper away from the negative after an

initial period in the sun (this was done in the shade) in order to determine its progress. The judgment that a print had received sufficient exposure was done on the spot and the standard of sufficiency varied with the person who was in charge of any given printing frame, negative, and paper combination. As a result, there was substantial latitude in the vigor of prints taken to have received satisfactory exposure.

The exposed print was then taken inside, where it was washed in two or three changes of water and then toned in an alkaline solution of dilute gold chloride. This "toning bath" gilded the silver that constituted the print and gave it a sepia hue. The print was then bathed in photographic fixer, and well washed in water. The final step in the process was to glue the print to a prepared mounting board (this was called "wet mounting" because prints were at this point still damp).

The variations in tone, depth of printing, and hue of albumen prints made from the same negative, even on the same day, is an inevitable feature of the process. The concentration of the silver sensitizing bath changed constantly as new sheets of albumen were floated upon it, even though fresh silver nitrate was added to replenish the bath. Moreover, the albumen itself reacted with the silver bath and slowly changed the way it worked. Likewise, print exposure varied, as did the concentration of the gold bath and the amount of time any given print was toned in the bath.

Most if not all of the "vintage" prints in the exhibition were printed by Timothy O'Sullivan or under his direct supervision. Printing, like negative-making, was something of a frenzied activity. Neither could be done at leisure.

NOTES

1. George M. Wheeler, "Photography–Miscellaneous," *Progress-Report upon Geographical and Geological Explorations and Surveys West of the One Hundredth Meridian, in 1872, under the Direction of Brig. Gen. A. A. Humphreys, Chief of Engineers, United States Army, by First Lieut. George M. Wheeler, Corps Of Engineers, in Charge* (Washington, D.C.: U.S. Government Printing Office, 1874), 11.

PLATES

NOTE

The captions given for each plate follow the convention of the
survey albums: photographer's name at left, plate number at right,
and title centered slightly lower. The plate numbers given
here are sequential for this catalogue and do not refer to
the numbering of the survey albums.

Timothy O'Sullivan

Plate № 1

MONO LAKE, CALIFORNIA, 1867

Timothy O'Sullivan

WAVE ROCK, EAST HUMBOLDT MOUNTAINS, NEVADA, 1867

Timothy O'Sullivan

Plate Nº 3

TOP OF ANAHO ISLAND, PYRAMID LAKE, WESTERN NEVADA, CA. 1867

TOP OF ANAHO ISLAND, PYRAMID LAKE, WESTERN NEVADA, CA. 1867

BLOODY CANYON, CALIFORNIA, 1868

Timothy O'Sullivan Plate № 6

CANYON OF LODORE, GREEN RIVER, WYOMING, 1868

Timothy O'Sullivan Plate № 7

EAST HUMBOLDT MOUNTAINS, NEVADA, 1868

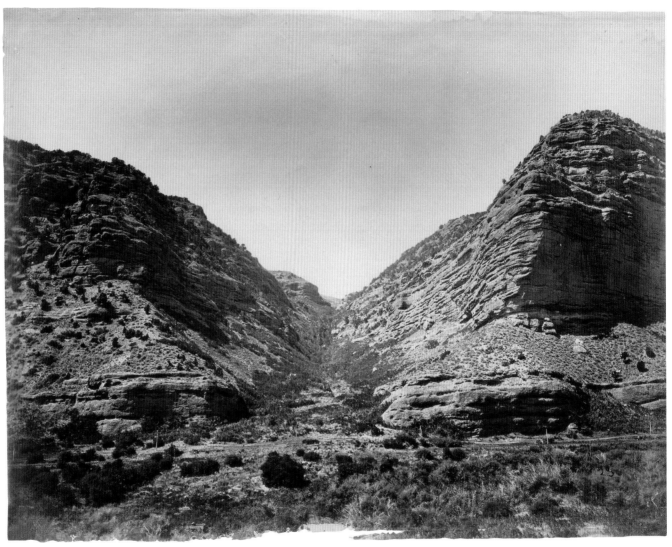

Timothy O'Sullivan Plate № 8

ECHO CANYON, UTAH, 1868

(Limestone Canyon near Fort Ruby, Nevada)

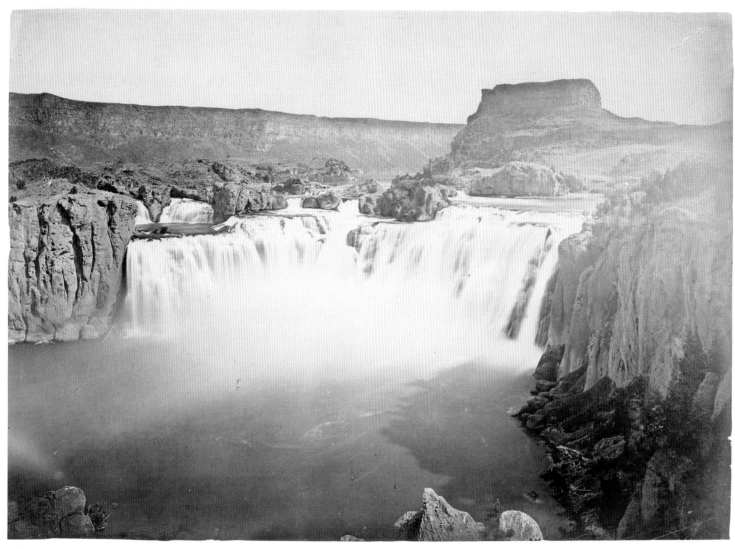

Timothy O'Sullivan Plate № 9

SHOSHONE FALLS, SNAKE RIVER, IDAHO, CA. 1868

Timothy O'Sullivan

Plate № 10

AMERICAN CANYON, WASATCH RANGE, 1869

Timothy O'Sullivan

Plate № 11

DEVIL'S SLIDE, 1869

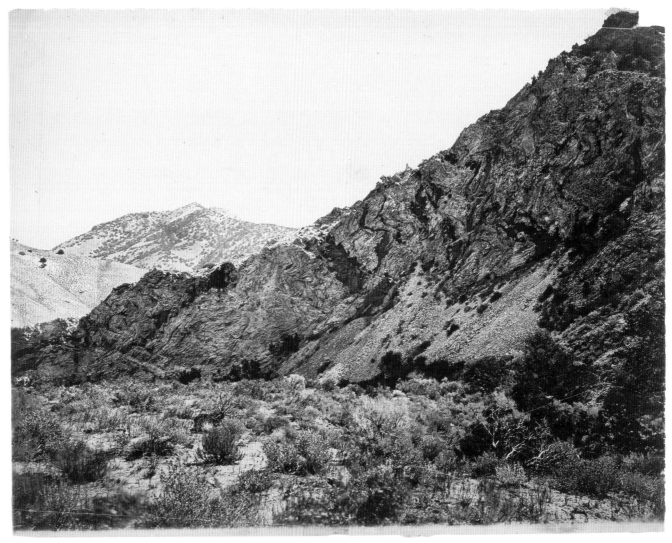

Timothy O'Sullivan Plate № 12

GARNET CANYON, UINTA MOUNTAINS, 1869

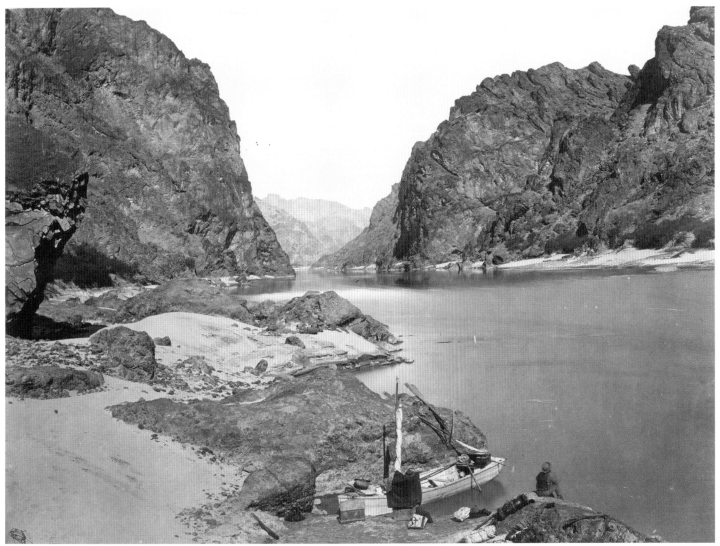

Timothy O'Sullivan

BLACK CANYON, COLORADO RIVER, 1871

Looking above from Camp 7

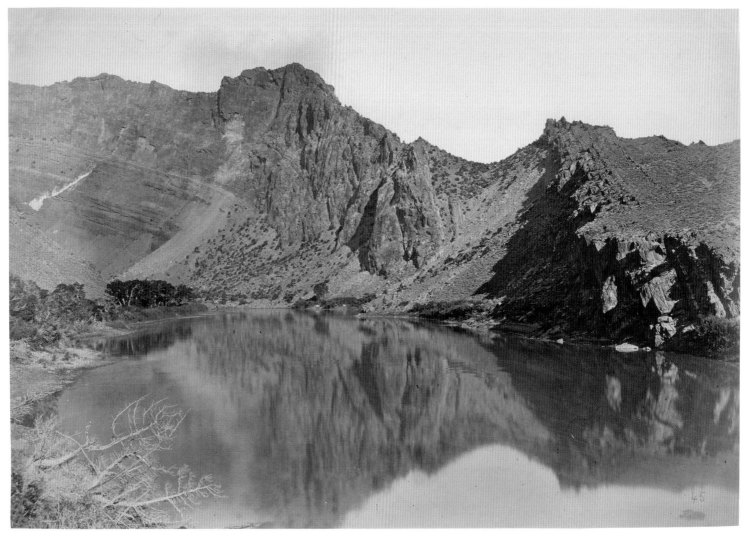

Timothy O'Sullivan

FLAMING GORGE, GREEN RIVER, 1872

Timothy O'Sullivan

Plate № 15

APACHE LAKE, SIERRA BLANCA RANGE, ARIZONA, 1873

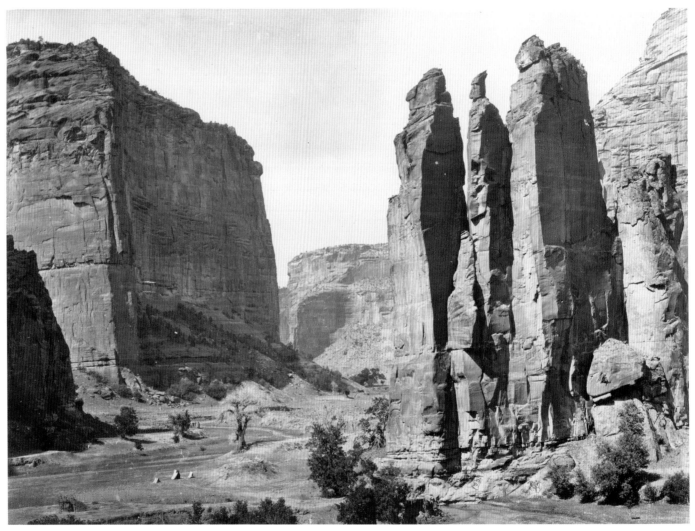

Timothy O'Sullivan Plate № 16

CANYON DE CHELLE, 1873

HISTORIC SPANISH RECORD OF THE CONQUEST, SOUTH SIDE OF
INSCRIPTION ROCK, NEW MEXICO TERRITORY, 1873

HISTORIC SPANISH RECORD OF THE CONQUEST, SOUTH SIDE OF
INSCRIPTION ROCK, NEW MEXICO TERRITORY, 1873

Timothy O'Sullivan

Plate №. 19

SECTION OF SOUTH SIDE OF ZUNI PUEBLO, NEW MEXICO, 1873

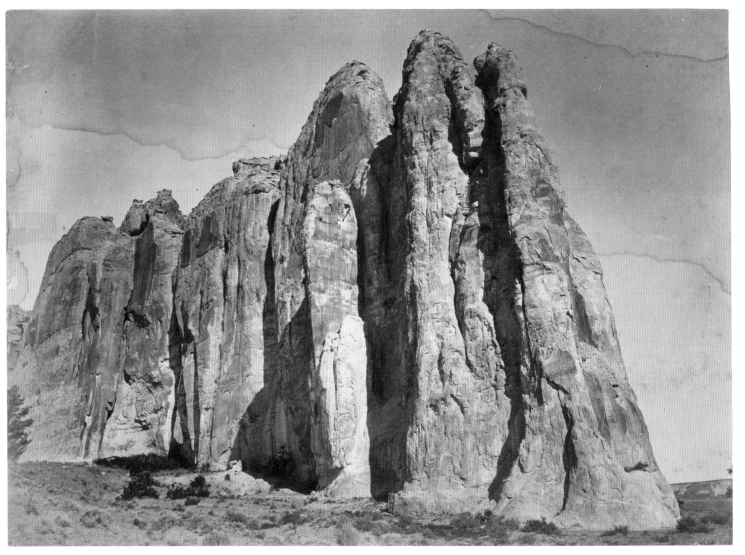

Timothy O'Sullivan Plate № 20

SOUTH SIDE OF INSCRIPTION ROCK, 1873

Timothy O'Sullivan

VIEW ON APACHE LAKE, SIERRA BLANCA RANGE, ARIZONA,
TWO APACHE SCOUTS IN THE FOREGROUND, 1873

Timothy O'Sullivan

Plate № 22

ALPINE LAKE, CERRO BLANCO MOUNTAINS, COLORADO, 1874

Timothy O'Sullivan

Plate № 23

LAKE IN CONEJOS CANYON, COLORADO, 1874

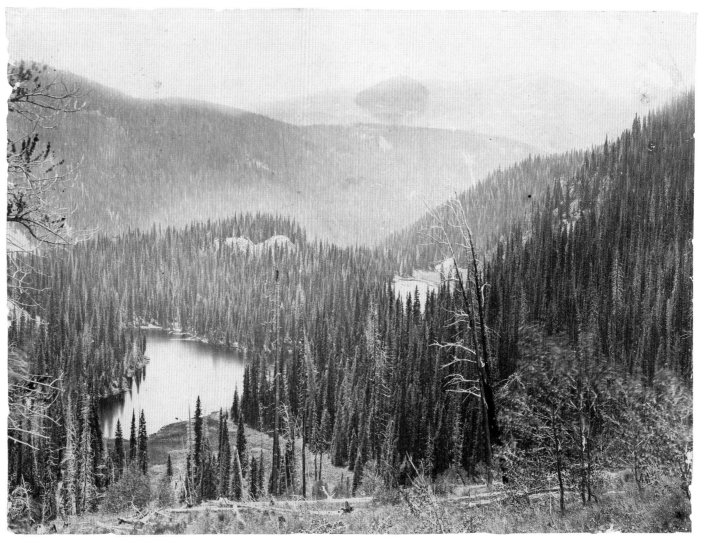

Timothy O'Sullivan

Plate № 24

"LOST" LAKES NEAR MEIGS PEAK, COLORADO, 1874

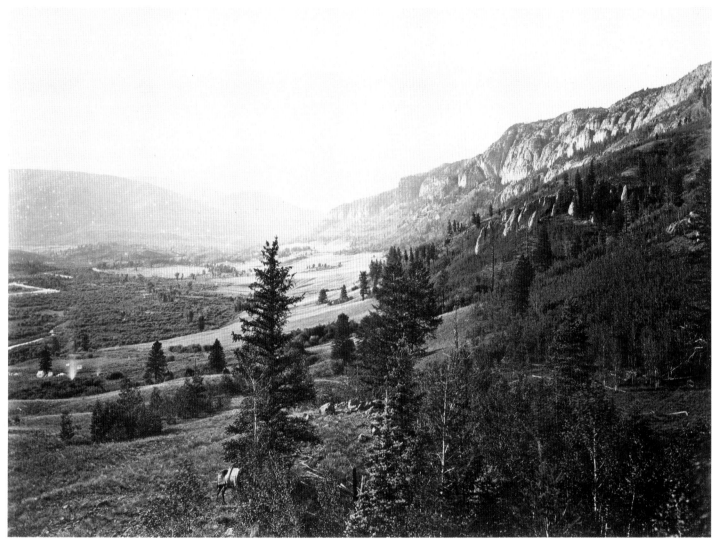

Timothy O'Sullivan Plate № 25

PARK NEAR HEAD OF CONEJOS CANYON, COLORADO, 1874

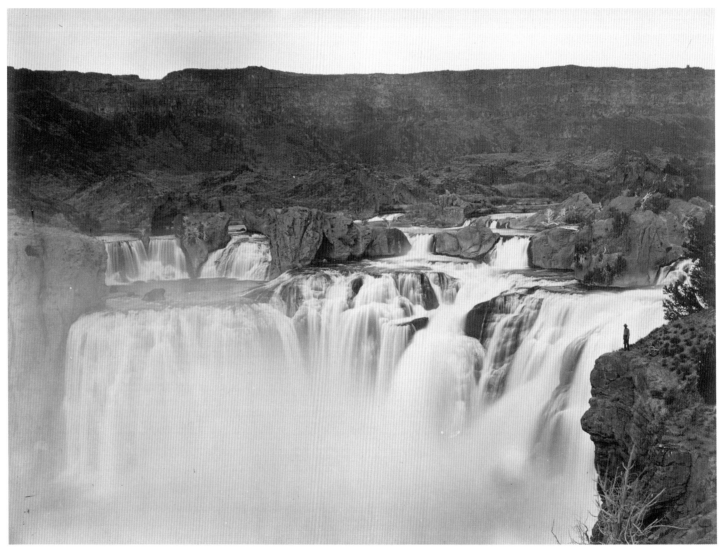

Timothy O'Sullivan

SHOSHONE FALLS, SNAKE RIVER, IDAHO, 1874

Full Lateral View on Upper Level

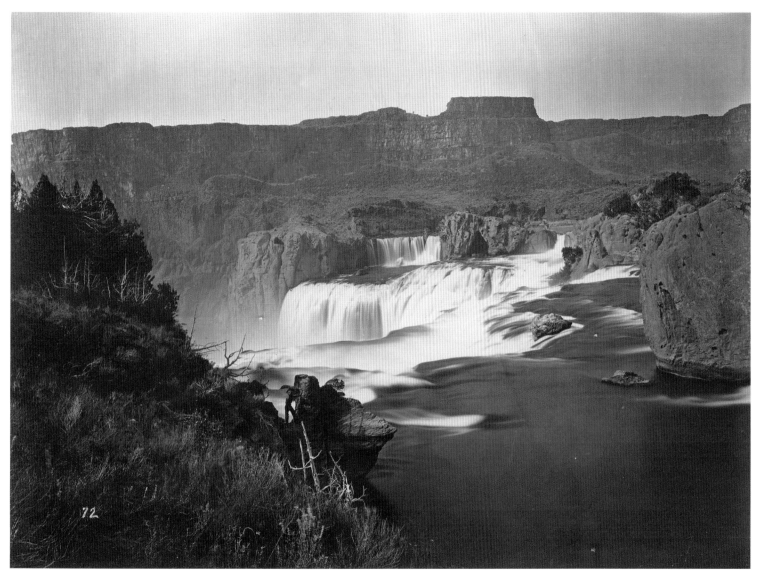

Timothy O'Sullivan

Plate № 27

SHOSHONE FALLS, SNAKE RIVER, IDAHO, 1874

Midday View, Adjacent Walls about 1000 Feet in Height

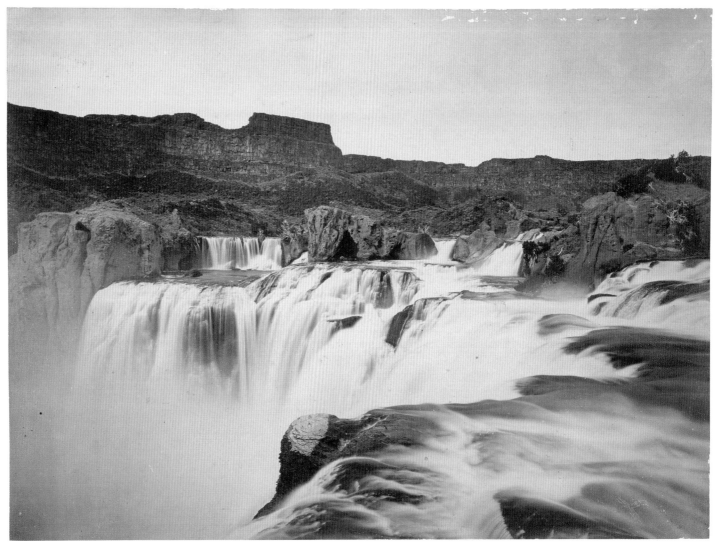

Timothy O'Sullivan Plate № 28

SHOSHONE FALLS, SNAKE RIVER, IDAHO, 1874

View across Top of the Falls

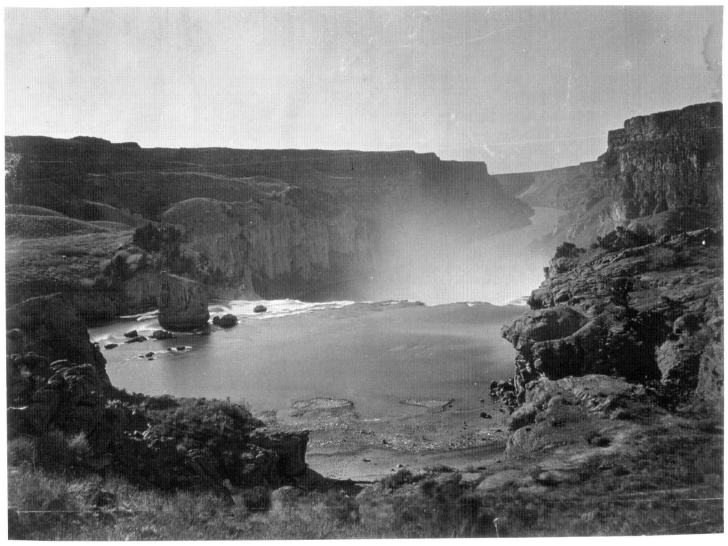

Timothy O'Sullivan Plate № 29

SNAKE RIVER CANYON, IDAHO, VIEW FROM ABOVE SHOSHONE FALLS, 1874

Timothy O'Sullivan

VIEW NEAR HEAD OF CONEJOS RIVER, COLORADO, 1874

William Bell Plate № 31

GRAND GULCH, ARIZONA, 1872

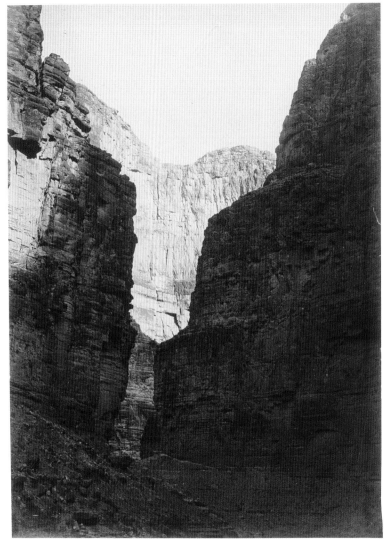

William Bell Plate № 32

LIMESTONE WALLS, KANAB WASH, COLORADO RIVER, 1872

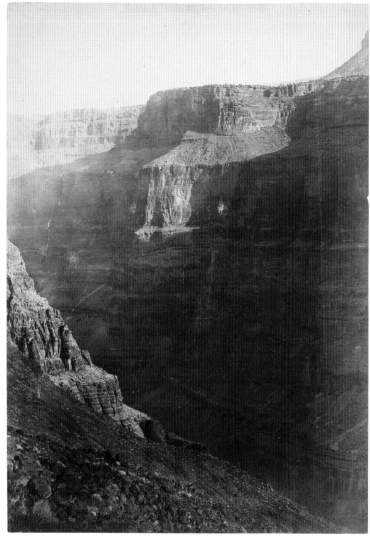

William Bell Plate № 33

WALLS OF THE GRAND CANYON, LOOKING EAST (COLORADO RIVER), 1872

Por aqui paso el Alferes Ca.
Joseph de Payba Basconzelos
el año que truxo el Cauildo del
Reyno a su costa a 18 de feb.
de 1526 Años =

Checklist of the Exhibition

All works in the collection of the David and Alfred Smart Museum of Art unless otherwise noted. Height precedes width in all measurements. All works are albumen prints unless otherwise indicated. All albumen prints described as "modern" were made by the Chicago Albumen Works, Housatonic, MA, in 1980.

TIMOTHY O'SULLIVAN
American, born Ireland, 1840–1882

1.
Mono Lake, California, 1867
8 ½ x 11 ⁵⁄₁₆ in. (21.6 x 28.7 cm)
Lent by Joel Snyder
Plate 1

2.
Silver Mine Shaft, Virginia City, Nevada, 1867
7 ⅛ x 8 ¹⁵⁄₁₆ in. (18.1 x 22.7 cm)
Lent by Joel Snyder

3.
Wave Rock, East Humboldt Mountains, Nevada, 1867
7 ¾ x 10 ⁹⁄₁₆ in. (19.7 x 26.8 cm)
Center for Creative Photography, University of Arizona, Tucson
2004:003:001
Plate 2

4.
Top of Anaho Island, Pyramid Lake, Western Nevada, ca. 1867
7 ⅞ x 11 ⅛ in. (20 x 28.3 cm)
Purchase, Gift of the Smart Family Foundation in honor of the 30th Anniversary of the Smart Museum
2003.147.26
Plate 3

5.
Top of Anaho Island, Pyramid Lake, Western Nevada, ca. 1867
7 ¾ x 11 in. (19.7 x 27.9 cm)
Purchase, Paul and Miriam Kirkley Fund for Acquisitions
2005.49.2
Plate 4

6.
Bloody Canyon, California, 1868
Albumen print mounted on board
7 ¾ x 11 ¹⁄₁₆ in. (19.7 x 28.1 cm)
Purchase, Gift of the Smart Family Foundation in honor of the 30th Anniversary of the Smart Museum
2003.147.33
Plate 5

7.
Canyon of Lodore, Green River, Wyoming, 1868
11 ¹⁄₁₆ x 7 ¾ in. (28.1 x 19.7 cm)
Purchase, Gift of the Smart Family Foundation in honor of the 30th Anniversary of the Smart Museum
2003.147.23
Plate 6

8.
East Humboldt Mountains, Nevada, 1868
9 x 11 ⅞ in. (22.9 x 30.2 cm)
Lent by Joel Snyder
Plate 7

Cat. 30

9.
Echo Canyon, Utah (Limestone Canyon near Fort Ruby, Nevada), 1868
8¾ x 11⅜ in. (22.2 x 28.9 cm)
Purchase, Gift of the Smart Family Foundation in honor of the
30th Anniversary of the Smart Museum
2003.147.27
Plate 8 and Figure 26

10.
Shoshone Falls, Snake River, Idaho, ca. 1868
7¹¹⁄₁₆ x 10¹³⁄₁₆ in. (19.5 x 27.5 cm)
Purchase, Gift of the Smart Family Foundation in honor of the
30th Anniversary of the Smart Museum
2003.147.29
Plate 9

11.
American Canyon, Wasatch Range, 1869
Albumen print mounted on board
7⅝ x 10¹⁵⁄₁₆ in. (19.4 x 27.8 cm)
Purchase, Gift of the Smart Family Foundation in honor of the
30th Anniversary of the Smart Museum
2003.147.35
Plate 10

12.
American Fork Canyon, Wasatch Mountains, Utah Territory, 1869
Modern albumen print
9¹⁄₁₆ x 11¹³⁄₁₆ in. (23 x 30 cm)
Lent by Joel Snyder

13.
Devil's Slide, 1869
8¹¹⁄₁₆ x 11½ in. (22.1 x 29.2 cm)
Purchase, Gift of the Smart Family Foundation in honor of the
30th Anniversary of the Smart Museum
2003.147.28
Plate 11

14.
Garnet Canyon, Uinta Mountains, 1869
Albumen print mounted on board
8⅜ x 11¾ in. (21.3 x 29.9 cm)
Purchase, Gift of the Smart Family Foundation in honor of the
30th Anniversary of the Smart Museum
2003.147.36
Plate 12

15.
Black Canyon, Arizona Territory, 1871
Modern albumen print
9⅛ x 7⅛ in. (23.2 x 18.1 cm)
Lent by Joel Snyder

16.
Black Canyon, Colorado River, Looking above from Camp 7, 1871
8 x 10⅞ in. (20.3 x 27.6 cm)
LaSalle Bank Photography Collection
73.76.10
Plate 13

17.
Black Canyon, Colorado River, Looking above from Camp 7, 1871
8 x 10¹³⁄₁₆ in. (20.3 x 27.5 cm)
Center for Creative Photography, University of Arizona, Tucson
76:024:005

18.
Mill Office, Hyko Mining Company, Hyko, Nevada, 1871
Modern albumen print
9½ x 11½ in. (24.1 x 29.2 cm)
Lent by Joel Snyder

19.
Ore Chutes, Eureka, Nevada, 1871
Modern albumen print
9¼ x 12¼ in. (23.5 x 31.1 cm)
Lent by Joel Snyder

20.
Pamranaset Lake District, Nevada, 1871
Modern albumen print
11⅝ x 9½ in. (29.5 x 24.1 cm)
Lent by Joel Snyder

21.
Flaming Gorge, Green River, 1872
7⅞ x 11¹/₁₆ in. (20 x 28.1 cm)
Purchase, Gift of the Smart Family Foundation in honor of the
30th Anniversary of the Smart Museum
2003.147.34
Plate 14

22.
Green River Canyon, Summit Valley, Colorado Territory, 1872
Modern albumen print
9¾ x 11⅝ in. (24.8 x 29.5 cm)
Lent by Joel Snyder

23.
Aboriginal Life among the Navajo Indians, 1873
10⅞ x 8 in. (27.6 x 20.3 cm)
LaSalle Bank Photography Collection
73.76.4

24.
Ancient Ruins in the Canyon de Chelle, New Mexico, 1873
10½ x 8 in. (26.7 x 20.3 cm)
LaSalle Bank Photography Collection
73.76.5
Figure 1

25.
Apache Lake, Sierra Blanca Range, Arizona, 1873
8 x 10¹³/₁₆ in. (20.3 x 27.5 cm)
Center for Creative Photography, University of Arizona, Tucson
76:024:016
Plate 15

26.
Canyon de Chelle, 1873
8 x 10⅞ in. (20.3 x 27.6 cm)
LaSalle Bank Photography Collection
73.76.7
Plate 16

27.
Cooley's Park, Arizona, 1873
Modern albumen print
9⅞ x 12 in. (25.1 x 30.5 cm)
Lent by Joel Snyder

28.
*Historic Spanish Record of the Conquest, South Side of Inscription
Rock, New Mexico Territory*, 1873
7¹¹/₁₆ x 10¾ in. (19.5 x 27.3 cm)
Purchase, Gift of the Smart Family Foundation in honor of the
30th Anniversary of the Smart Museum
2003.147.24
Plate 17

29.
*Historic Spanish Record of the Conquest, South Side of Inscription
Rock, New Mexico Territory*, 1873
7¾ x 10¾ in. (19.7 x 27.3 cm)
Purchase, Paul and Miriam Kirkley Fund for Acquisitions
2005.49.1
Plate 18

30.
Inscription Rock, 1873
7¹⁵/₁₆ x 10¹³/₁₆ in. (20.2 x 30 cm)
Collection of Michael Mattis and Judith Hochberg

31.
Oak Grove, Sierra Blanca Range, Arizona Territory, 1873
Modern albumen print
10 x 11^{15}/$_{16}$ in. (25.4 x 30.3 cm)
Lent by Joel Snyder

32.
Section of South Side of Zuni Pueblo, New Mexico, 1873
8 x 10^{7}/$_{8}$ in. (20.3 x 27.6 cm)
LaSalle Bank Photography Collection
73.76.1
Plate 19

33.
South Side of Inscription Rock, 1873
7^{3}/$_{4}$ x 10^{3}/$_{4}$ in. (19.7 x 27.3 cm)
Purchase, Gift of the Smart Family Foundation in honor of the
30th Anniversary of the Smart Museum
2003.147.5
Plate 20

34.
*View on Apache Lake, Sierra Blanca Range, Arizona, Two Apache
Scouts in the Foreground*, 1873
8 x 10^{13}/$_{16}$ in. (20.3 x 27.5 cm)
Center for Creative Photography, University of Arizona, Tucson
76:024:017
Plate 21

35.
Alpine Lake, Cerro Blanco Mountains, Colorado, 1874
7^{7}/$_{8}$ x 10^{3}/$_{4}$ in. (20 x 27.3 cm)
LaSalle Bank Photography Collection
73.76.3
Plate 22

36.
Lake in Conejos Canyon, Colorado, 1874
8 x 10^{7}/$_{8}$ in. (20.3 x 27.6 cm)
LaSalle Bank Photography Collection
73.76.11
Plate 23

37.
"Lost" Lakes near Meigs Peak, Colorado, 1874
8^{1}/$_{16}$ x 10^{7}/$_{8}$ in. (20.5 x 27.6 cm)
Purchase, Gift of the Smart Family Foundation in honor of the
30th Anniversary of the Smart Museum
2003.147.22
Plate 24

38.
Park near Head of Conejos Canyon, Colorado, 1874
8 x 10^{3}/$_{4}$ in. (20.3 x 27.3 cm)
LaSalle Bank Photography Collection
73.76.8
Plate 25

39.
*Shoshone Falls, Snake River, Idaho, Full Lateral View on
Upper Level*, 1874
7^{7}/$_{8}$ x 10^{3}/$_{4}$ in. (19.9 x 27.3 cm)
Center for Creative Photography, University of Arizona, Tucson
76:254:004
Plate 26

40.
Shoshone Falls, Snake River, Idaho, Midday View, 1874
8^{1}/$_{16}$ x 10^{15}/$_{16}$ in. (20.5 x 27.8 cm)
Purchase, Gift of the Smart Family Foundation in honor of the
30th Anniversary of the Smart Museum
2003.147.31
Frontispiece

41.
Shoshone Falls, Snake River, Idaho, Midday View, Adjacent Walls about 1000 Feet in Height, 1874
7¾ x 10⅝ in. (19.7 x 27 cm)
Collection of Michael Mattis and Judith Hochberg
Plate 27

42.
Shoshone Falls, Snake River, Idaho, View across Top of the Falls, 1874
8¹⁄₁₆ x 10⅞ in. (20.5 x 27.6 cm)
Purchase, Gift of the Smart Family Foundation in honor of the 30th Anniversary of the Smart Museum
2003.147.30
Plate 28

43.
Shoshone Falls, Snake River, Idaho, View across Top of the Falls, 1874
7⅞ x 10¾ in. (19.9 x 27.3 cm)
Center for Creative Photography, University of Arizona, Tucson
76:254:005
Figure 3

44.
Snake River Canyon, Idaho, View from above Shoshone Falls, 1874
7¹¹⁄₁₆ x 10¾ in. (19.5 x 27.3 cm)
Purchase, Gift of the Smart Family Foundation in honor of the 30th Anniversary of the Smart Museum
2003.147.32
Plate 29

45.
View near Head of Conejos River, Colorado, 1874
7⅞ x 10¾ in. (20 x 27.3 cm)
Center for Creative Photography, University of Arizona, Tucson
76:254:008
Plate 30 and Figure 17

WILLIAM BELL
American, 1830–1910

46a–e.
Canyon and Headlands of Colorado and Paria Rivers (beneath the Vermilion Cliffs), 1872
Panorama; four albumen prints and one modern print from original negative
From left to right: 7¾ x 10¾ in. (19.7 x 27.3 cm); 8⅞ x 11¹³⁄₁₆ in. (22.5 x 30 cm); print not in exhibition; 8⁷⁄₁₆ x 10¼ in. (21.4 x 26 cm); 8¾ x 11¹⁄₁₆ in. (22.2 x 28.1 cm)
Purchase, Gift of the Smart Family Foundation in honor of the 30th Anniversary of the Smart Museum; Purchase, Paul and Miriam Kirkley Fund for Acquisitions
2003.147.7, 2003.147.8, National Archives and Records Administration image, 2005.49.3, 2003.147.2
Figure 20

47.
Canyon of Kanab Wash, Colorado River, Looking North, 1872
10¾ x 8 in. (27.4 x 20.3 cm)
The Art Institute of Chicago, Photography Gallery Fund
1959.615.10

48.
Canyon of Kanab Wash, Colorado River, Looking South, 1872
10¹³⁄₁₆ x 8 in. (27.5 x 20.3 cm)
The Art Institute of Chicago, Photography Gallery Fund
1959.615.11

49a–f.
Grand Canyon, Colorado River, Arizona (from Vulcan's Throne, near Toroweap, looking south and west), 1872
Panorama; six albumen prints
From left to right: 9 x 11¼ in. (22.9 x 28.6 cm); 8⅞ x 11⅞ in. (22.5 x 30.2 cm); 8³⁄₁₆ x 11⁵⁄₁₆ in. (20.8 x 28.7 cm); 8⅝ x 11½ in. (22 x 29.2 cm); 8⅞ x 11⁵⁄₁₆ in. (22.5 x 28.7 cm); 9 x 10¹⁵⁄₁₆ in. (22.9 x 27.8 cm)
Purchase, Gift of the Smart Family Foundation in honor of the 30th Anniversary of the Smart Museum
2003.147.13, 2003.147.12, 2003.147.11, 2003.147.15, 2003.147.17, 2003.147.18
Figures 18 and 19

50.
Grand Canyon, Colorado River, near Paria Creek, Looking West, 1872
10¾ x 7⅞ in. (27.4 x 20.1 cm)
The Art Institute of Chicago, Photography Gallery Fund
1959.615.14

51.
Grand Canyon, Colorado River, near Paria Creek, Looking West, 1872
10¹³⁄₁₆ x 7⅞ in. (27.5 x 20.1 cm)
The Art Institute of Chicago, Photography Gallery Fund
1959.615.15

52.
Grand Canyon of the Colorado River, Mouth of Kanab Wash, Looking East, 1872
10¹¹⁄₁₆ x 7⅞ in. (27.2 x 20 cm)
The Art Institute of Chicago, Photography Gallery Fund
1959.615.42

53.
Grand Canyon of the Colorado River, Mouth of Kanab Wash, Looking West, 1872
10¾ x 7⅞ in. (27.4 x 20.1 cm)
The Art Institute of Chicago, Photography Gallery Fund
1959.615.41

54.
Grand Canyon of the Colorado River, Mouth of Kanab Wash, Looking West, 1872
10¾ x 8 in. (27.4 x 20.3 cm)
The Art Institute of Chicago, Photography Gallery Fund
1959.615.43

55.
Grand Gulch, Arizona, 1872
11 x 7¹³⁄₁₆ in. (27.9 x 19.8 cm)
Purchase, Gift of the Smart Family Foundation in honor of the 30th Anniversary of the Smart Museum
2003.147.3
Plate 31

56.
Limestone Walls, Kanab Wash, Colorado River, 1872
10¹³⁄₁₆ x 7¹³⁄₁₆ in. (27.5 x 19.8 cm)
Purchase, Gift of the Smart Family Foundation in honor of the 30th Anniversary of the Smart Museum
2003.147.21
Plate 32

57.
Limestone Walls, Kanab Wash, Colorado River, 1872
10¹³⁄₁₆ x 7⅞ in. (27.5 x 20.1 cm)
The Art Institute of Chicago, Photography Gallery Fund
1959.615.49

58.
Looking South into the Grand Canyon, Colorado River,
Sheavwitz Crossing, 1872
10 $^{11}/_{16}$ x 7 $^{7}/_{8}$ in. (27.2 x 20.1 cm)
The Art Institute of Chicago, Photography Gallery Fund
1959.615.44

59.
Rain Sculpture, Salt Creek Canyon, Utah, 1872
10 $^{3}/_{4}$ x 7 $^{7}/_{8}$ in. (27.3 x 20.1 cm)
The Art Institute of Chicago, Photography Gallery Fund
1959.615.31

60.
Walls of the Grand Canyon, Looking East (Colorado River), 1872
11 $^{1}/_{8}$ x 7 $^{13}/_{16}$ in. (28.3 x 19.8 cm)
Purchase, Gift of the Smart Family Foundation in honor of the
30th Anniversary of the Smart Museum
2003.147.4
Plate 33

WILLIAM HENRY JACKSON
American, 1843–1942

(All are albumen prints from the Hayden Survey, 1870–78,
Special Collections Research Center, University of Chicago
Library, QE74 f.H65)

61.
Castellated Ruins near Monument Park
11 x 13 $^{15}/_{16}$ in. (27.9 x 35.4 cm)

62.
Grand Lake, Distant View from Foot of Round Top Mt.
11 x 13 $^{15}/_{16}$ in. (27.9 x 35.4 cm)

63.
Looking North from the Mouth of the Blue. Middle Park
11 x 13 $^{15}/_{16}$ in. (27.9 x 35.4 cm)

64.
Middle Park East from Mt. Bross
11 x 13 $^{15}/_{16}$ in. (27.9 x 35.4 cm)

65.
Middle Park View up the Grand from the Blue
11 x 13 $^{15}/_{16}$ in. (27.9 x 35.4 cm)

66.
Mountain of the Holy Cross
16 x 20 in. (40.6 x 50.8 cm)

67.
Upper Fire Hole, from "Old Faithful"
16 x 20 in. (40.6 x 50.8 cm)

68.
Upper Twin Lake, Colorado
21 $^{7}/_{8}$ x 27 in. (55.6 x 68.6 cm)

NON-PHOTOGRAPHIC MATERIAL

69.
After Timothy O'Sullivan
Beaver Park, Valley of Conejos River, Colorado
Reproduced in George M. Wheeler, *Report upon United States*
Geographical Surveys West of the One Hundredth Meridian, vol. 1
(*Geographical Report*), plate 13
University of Chicago Library
QE74.W6
Figure 15

70.
After Timothy O'Sullivan
Horse Shoe Curve, Green River, Wyoming
Reproduced in Clarence King, *Report of the Geological
Exploration of the Fortieth Parallel*, vol. 2 (*Descriptive Geology*),
plate 1
University of Chicago Library
QE74.K5

71.
After Timothy O'Sullivan
Shoshone Falls, Idaho, From Above
Reproduced in Clarence King, *Report of the Geological
Exploration of the Fortieth Parallel*, vol. 1 (*Systematic Geology*),
plate 18
University of Chicago Library
QE74.K5

72.
After William Bell
*Grand Canyon of the Colorado, Mouth of Kanab Wash, Looking
East*
Reproduced in George M. Wheeler, *Progress-Report upon
Geographical and Geological Explorations and Surveys West of the
One Hundredth Meridian, in 1872*, plate 4
University of Chicago Library
QE74.W56

73.
After William Bell
*Looking South into the Grand Canyon, Colorado River, Sheavwitz
Crossing*
Reproduced in George M. Wheeler, *Progress-Report upon
Geographical and Geological Explorations and Surveys West of the
One Hundredth Meridian, in 1872*, plate 5
University of Chicago Library
QE74.W56
Figure 29

74.
After William Bell
*Looking South into the Grand Canyon, Colorado River, Sheavwitz
Crossing*
Reproduced in George M. Wheeler, *Report upon United States
Geographical Surveys West of the One Hundredth Meridian*, vol. 1
(*Geographical Report*), plate 21
University of Chicago Library
QE74.W6

75.
After William Bell
Rain Sculpture, Salt Creek Canyon, Utah
Reproduced in George M. Wheeler, *Report upon United States
Geographical Surveys West of the One Hundredth Meridian*, vol. 3
(*Geology*), plate 1
University of Chicago Library
QE74.W6

76.
*Sketch indicating the advancement of the surveys of the public
lands and the military, topographical, and geographical surveys
west of the Mississippi. Prepared under the direction of 1st Lieut.
Geo. M. Wheeler, Corps of Engineers, U.S. Army, 1879*
Survey map
36⁵/₁₆ x 46 in. (92.2 x 118.8 cm), framed
Lent by Joel Snyder
Endsheets (detail)

77a–d.
United States Army Corps of Engineers, *Topographical atlas,
projected to illustrate explorations and surveys west of the 100th
meridian of longitude*, 1873–1875
Title pages and atlas sheets 66 and 67
19¼ x 24³/₈ in. (49 x 62 cm), each
University of Chicago Library Map Collection
G4050 1873.U5

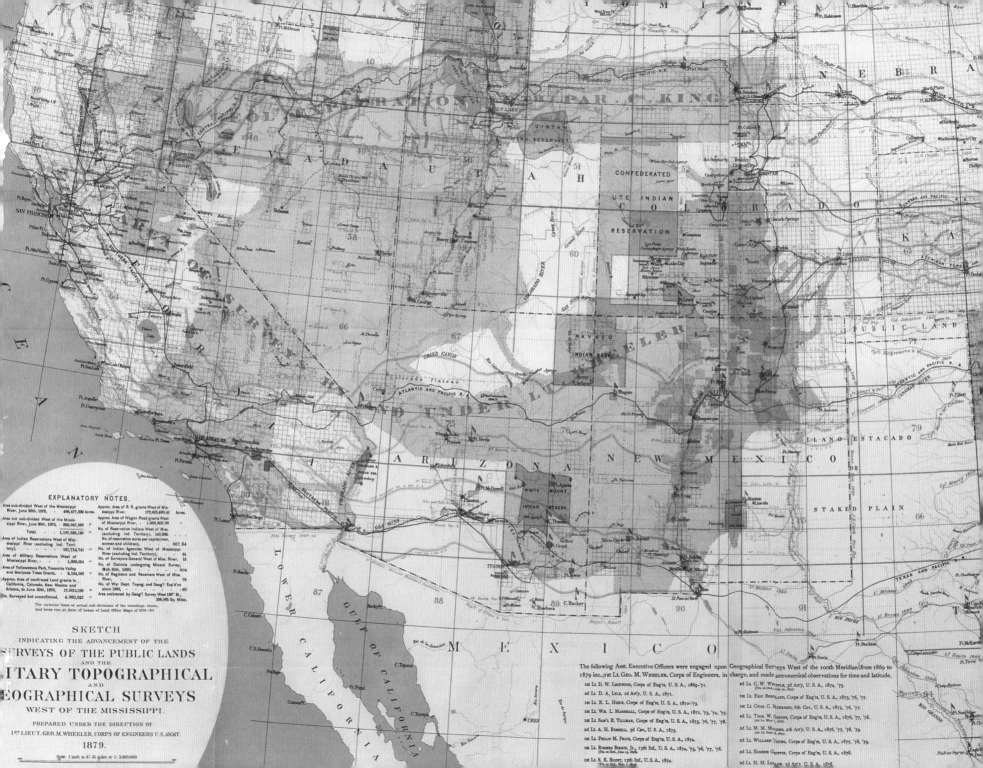

NEBRASKA

KANSAS

NEVADA · UTAH

CONFEDERATED UTE INDIAN RESERVATION

COLORADO

GEOLOGICAL EXPLORATION 40th PAR. C. KING

CALIFORNIA

NAVAJO INDIAN RESERV.

LAND UNDER LT. WHEELER

GRAND CANYON

Colorado Plateau

ATLANTIC AND PACIFIC R.R.

ARIZONA · NEW MEXICO

LLANO ESTACADO

PUBLIC LAND

WHITE MOUNT INDIAN RESERV.

STAKED PLAIN

SOUTHERN PACIFIC R.R.

LOWER CALIFORNIA

GULF OF CALIFORNIA

M E X I C O

TEXAS

RIO GRANDE

EXPLANATORY NOTES.

Area sub-divided West of the Mississippi River, June 30th, 1879, . . . 488,477,029 Acres.
Area not sub-divided West of the Mississippi River, June 30th, 1879, . 699,047,509
Total, 1,187,585,190
Area of Indian Reservations West of Mississippi River (excluding Ind. Territory), 191,714,741
Area of Military Reservations West of Mississippi River, . . . 1,836,054
Area of Yellowstone Park, Yosemite Valley and Mariposa Trees Grants, . . 3,184,083
Approx. Area of confirmed Land grants in California, Colorado, New Mexico and Arizona, to June 30th, 1879, 17,963,5,196
Do. Surveyed but unconfirmed, . 4,963,542

Approx. Area of R. R. grants West of Mississippi River, . . 172,683,490.41 Acres.
Approx. Area of Wagon Road grants West of Mississippi River, . 1,863,400.00
No. of Reservation Indians West of Miss. (excluding Ind. Territory), 140,953
No. of reservation acres per capita (men, women and children), . . 867.64
No. of Indian Agencies West of Mississippi River (excluding Ind. Territory), . 61
No. of Surveyors-General West of Miss. River, 15
No. of Districts undergoing Mineral Survey, Mch 20th, 1880, . . . 804
No. of Registers and Receivers West of Miss. River, 78
No. of War Dept. Topog. and Geog'l Exp'd'ns since 1800, . . . 80
Area embraced by Geog'l Survey West 100° M., 359,065 Sq. Miles.

The exterior lines or actual sub-divisions of the townships shown, had been run at date of issue of Land Office Maps of 1879-80.

SKETCH
INDICATING THE ADVANCEMENT OF THE
SURVEYS OF THE PUBLIC LANDS
AND THE
MILITARY TOPOGRAPHICAL
AND
GEOGRAPHICAL SURVEYS
WEST OF THE MISSISSIPPI.

PREPARED UNDER THE DIRECTION OF
1ST LIEUT. GEO. M. WHEELER, CORPS OF ENGINEERS U.S. ARMY.

1879.

Scale 1 inch to 47.35 miles or 1:3,000,000

The following Asst. Executive Officers were engaged upon Geographical Surveys West of the 100th Meridian (from 1869 to 1879 inc.,)1st Lt. Geo. M. Wheeler, Corps of Engineers, in charge, and made astronomical observations for time and latitude.

1st Lt. D. W. Lockwood, Corps of Eng'rs, U.S.A., 1869-'71.
2d Lt. D. A. Lyle, 2d Art'y, U.S.A., 1871.
1st Lt. R. L. Hoxie, Corps of Eng'rs, U.S.A., 1872-'73.
1st Lt. Wm. L. Marshall, Corps of Eng'rs, U.S.A., 1872, '73, '74, '75.
1st Lt. Sam'l E. Tillman, Corps of Eng'rs, U.S.A., 1873, '76, '77, '78.
2d Lt. A. H. Russell, 3d Cav., U.S.A., 1873.
1st Lt. Philip M. Price, Corps of Eng'rs, U.S.A., 1874.
1st Lt. Rogers Birnie, Jr., 13th Inf., U.S.A., 1874, '75, '76, '77, '78.
(Trs. to Ord., June 13, 1876.)
1st Lt. I. S. E. Blunt, 13th Inf., U.S.A., 1874.
(Trs. to Ord., Nov. 5, 1874.)

2d Lt. C. W. Whipple, 3d Art'y, U.S.A., 1874, '75.
(Trs. to Ord., July 19, 1875.)
1st Lt. Eric Bergland, Corps of Eng'rs, U.S.A., 1875, '76, '77.
1st Lt. Chas. C. Morrison, 6th Cav., U.S.A., 1875, '76, '77.
2d Lt. Thos. W. Symons, Corps of Eng'rs, U.S.A., 1876, '77, '78.
(1st Lt. May 1, 1876.)
2d Lt. M. M. Macomb, 4th Art'y, U.S.A., 1876, '77, '78.
(1st Lt. Sept. 8, 1877.)
2d Lt. Willard Young, Corps of Eng'rs, U.S.A., 1877, '78, '79.
2d Lt. Eugene Griffin, Corps of Eng'rs, U.S.A., 1878.
2d Lt. H. H. Ludlow, 2d Art'y, U.S.A., 1878.